MIRO

UMBRO APOLLONIO

THAMES AND HUDSON

Translated from the Italian by Victor Corti

This edition © 1969 Thames and Hudson Ltd, London
Copyright © 1969 by Sadea Editore, Firenze

Published in the United States in 1989 by Thames and Hudson Inc.,
500 Fifth Avenue, New York, New York 10110

Library of Congress Catalog Card Number 89-50718

Printed in Italy

Life

Many artists' lives ultimately become legends, transfigured by the testimony of those who were close to them; but Joan Miró has neither cloaked his life in mystery nor offered any pretext for it to be turned into anything excessively singular. Those who know him are agreed in this. Jacques Dupin, perhaps his most accurate interpreter, states, at the beginning of the essay he dedicated to him: 'No greater contrast can be imagined than that which exists between the imaginative power, the passionate drive, the grim humour and the elaborately cultivated delirium of Miró's art, on the one hand, and his appearance and habits on the other. He is a short, stocky man who moves and speaks with the slow deliberateness of a peasant, never pushing himself forward. In his life, this dreamer par excellence displays the same meticulousness, the same scrupulous attention to detail that must have characterized his father, who was a goldsmith, and his grandfather, who was a blacksmith.'

This does not, however, mean that events in the life of an artist are without importance, or that they do not lead to a better understanding of his creative vocation or of the forms of its expression.

Born in Barcelona in 1893, he already attended drawing classes at the age of seven, and at twelve he made sketches from life in the countryside around Tarragona and Palma de Mallorca. While continuing to follow commercial studies, he did not neglect artistic practice and was a pupil of the art school at La Lonja, which Picasso had attended ten years earlier, and where two teachers, the painter Modesto Urgell and the craftsman José Pasco, gave him much help. Although his artistic inclinations had shown themselves at a very early age, in 1910 he was obliged to take employment as a bookkeeper in the Barcelona firm of Dalmau Oliveros, his parents not sharing the confidence shown in him by his two teacher friends. What would have become of Miró if, after two years of submission and renunciation, the unhap-

piness of his position had not brought on severe nervous exhaustion? It is true that an artistic life entails a great deal of stress, but is also produces apparently accidental factors which allow the artist to escape from that stress. And it was certainly because of his illness that his family's opposition was permanently overcome, and that Montroig, the family property acquired only shortly before and where he passed his convalescence, became a favourite haunt for Miró, almost symbolic of his art and existence, continually revisited from year to year.

Freed therefore from any obligation contradictory to his artistic disposition, Miró continued to make drawings from life. He was still rather awkward, and one could not have said he showed any exceptional qualities. The Escola d'Art in Barcelona, run by Francisco Galí, stimulated his gifts and gave him an attitude of mind. Galí's school had an atmosphere of lively modernity and open nonconformism. Musical recitals were held there; Cézanne, van Gogh and Gauguin were discussed. Meanwhile, although principally attracted to Matisse and the fauve painters, Miró came into direct contact with cubist works, still on show in 1912 at the Dalmau gallery. The strong impression they made was reflected only shortly after in his paintings. Thus, Miró completed his first experiments, found his own bearings clearly, discovered his resources and developed intellectual maturity.

Barcelona was not lacking in factors to nourish and perfect his application. He was persistent and hard-working; he did not let himself stray from what he had seen and learnt at first-hand, and thus did not become a merely imitative artist. Nonetheless he lost no opportunity to increase his own stock of ideas. Friendships became more lasting, meetings more important. In 1915, while he was still with Galí, for three years he became a regular of the Sant Lluch circle, a kind of free school of drawing, where the aged architect Antoni Gaudí still went. Miró, who had already made great friends at Galí's with E. C. Ricart, with whom he shared a studio in 1915, struck up friendships at the Sant Lluch circle with Joan Prats, J. F. Rafols and the ceramic artist Llorens Artigas. Artigas was the animator of the

Agrupacio Courbet, founded in 1918, Miró participating in this avant-garde initiative with his friends; he was also the first to dedicate an essay to Miró. The two men have maintained close ties, and have worked together right up to their recent creation *Madonna of the sea* (1968).

Miró's life now ran more smoothly. He unwillingly accepted a monthly allowance from his family, but became more and more anxious to be independent. In March 1918 his first one-man show was held by Dalmau, who had already encouraged him two years earlier when he had showed him his work. However, in 1916 he had admired the French art at an exhibition organized by Ambroise Vollard at Barcelona, and in 1917 he had met Francis Picabia, who had arrived from New York with Marie Laurencin, and who was shortly to be joined by Max Jacob. His first contacts with a surrealist state of mind date from that time, when Picabia published the journal *391*. Some years earlier he had read the poems of Guillaume Apollinaire and Paul Reverdy, and he met the critic Maurice Reynal at Dalmau's in 1916. Paris attracted him irresistibly; Artigas had already been there for some months when Miró joined him in March 1919, immediately visiting Picasso.

Miró's true artistic life, in the sense of independent, fertile and original creation, began in 1920. However, he did not stay in Paris all the time; normally he spent his winters there and returned to Montroig during the summer. The incalculable significance this region assumed for him – the true mental and emotional mould for his work – is illustrated by the fact that in the autumn of 1920, he packed grass from Montroig in his suitcase and took it to Paris to continue the painting *The Farm*, which he completed the following year in Paris and which was bought by Ernest Hemingway in 1925. How can one explain such realism in an artist so inclined to the fabulous and surreal? His own inspiration sprang from fierce emotion, but emotion based on a strong understanding of reality. His tendency to surrealism did not arise from dreaming, but from ideas lying deep beneath the surface of reality. In fact he confessed: ' I need to paint tramping the earth, for strength enters through one's feet.'

In 1920 he once more met Reynal, who in the following year presented his first one-man show at the Galerie La Licorne, where he met Pierre Reverdy, Tristan Tzara and André Masson. Masson was his neighbour in the Rue Blomet, where Pablo Gargallo, another Paris-based Spaniard, who spent the winter in Barcelona fulfilling his obligations as professor at that city's Academia de Bellas Artes, temporarily lent Miró the use of his studio; until then he had lived in a hotel. He became close friends with Masson, and through him with Michel Leiris, Georges Limbour, Antonin Artaud, Jacques Prévert, Armand Salacrou and others who formed a group with Masson. In 1920 he attended the Dada festival. By this time he had seen Klee's and also Kandinsky's works. In 1923 he began *The Ploughed Field,* which marked the appearance of a stronger element of fantasy in his work.

The following year he was close to André Breton's surrealist group, although not in a truly active way; he shared their spirit and made contributions which display a wonderful intelligence, such as the ' poem-paintings ' of 1925. Breton recognized that Miró's tumultuous entry in 1924 marked an important date in the development of surrealist art. And this is an equally important date for Miró himself, who, as Breton goes on to say, in one bound cleared the last barrier still standing in the way of complete spontaneity of expression. Despite this, Miró never adhered slavishly to surrealist theory and practice, which were frequently marked by excessive intolerance. When, in 1926, he collaborated with Max Ernst on the production of the ballet *Romeo and Juliet* for Diaghilev, by painting the drop-curtain and making production designs, Breton and Aragon organized a protest demonstration at the Théâtre Sarah Bernhardt.

Henceforth he was a member of one of the richest and most advanced spheres of European artistic life, that which evolved in the favourable and receptive climate of the French capital. He undewent great hardships during his first years in Paris: ' My clothes were torn, and that stove that we had paid 45 francs for at the flea market did not work. Nevertheless the studio was spotless. I did the cleaning

myself. And since I was very poor, I could only afford lunch once a week '. This ordeal was, however, followed by more favourable conditions of life. The dealer Jacques Viot, with whom he had signed a contract, organized a showing for him, with a brochure by Benjamin Péret, at the Galerie Pierre. This aroused widespread interest, making up in some way for the poor result experienced some four years earlier.

His behaviour remained modest and reserved; he in no way imitated the flamboyant, insolent pose which distinguished several of the surrealists. Among them, Miró always appeared rather detached and carefully dressed. It was Masson who said he combined British elegance and Catalan correctness; and Jacques Viot, in speaking of the private view for the exhibition at the Galerie Pierre, observed how the very numerous visitors must have found it difficult to discover any connection between the extraordinary fantasy of his works and the grace and refinement of their author.

In 1927 he was finally able to have his own studio at his disposal in the Rue Tourlaque, in the Cité des Fusains at Montmartre, where Henri de Toulouse-Lautrec and André Derain had worked, and where Pierre Bonnard, Max Ernst and René Magritte then lived, as well as Jean Arp and Paul Eluard, both of whom became his close friends.

In the spring of the following year, he went to Holland and was greatly impressed by Vermeer, and other seventeenth-century masters, who inspired him to painting the famous *Dutch Interiors* with which, in terms of witty and malicious invention, he carried out the same transformations of the given object which he had already applied to nature. ' I succeeded in escaping into the absoluteness of nature, and my landscapes have nothing to do with external reality ', he wrote to his friend J. F. Rafols in 1923. After such fluctuations between expression in the fauve style and realistic stylization, more lyrical than visionary, ' what interests me above all ', he confided to Ricart, ' is the tiles on a roof, the calligraphy of a tree, leaf by leaf and branch by branch, blade of grass by blade of grass '.

After having absorbed cubist influences, Miró's imaginative

energy expanded with much greater autonomy and originality. This happened during 1930; meanwhile he had married Pilar Juncosa and settled in Paris. His painting was no longer either dreamlike or festive; wit had been replaced by the grotesque. The collages dating from 1929 reveal an inclination towards the dadaist spirit, whose manifestations he had followed since 1920, but of which he had not hitherto seemed to take much account. Now, Miró rebelled against attractiveness in painting and turned to anti-painting, having become convinced that 'painting has been decadent since the cave age.' He reviewed his previous work, as if to question it, and, when he began again, he resumed it on a new basis. One might say the breach with the surrealists became final when the latter engaged in direct revolutionary political activity, since for Miró an artist practises revolution in his works, which constitute not only a testimony to his hopes of a higher form of civilization, but also an act of condemnation against all subservience, and therefore of respect for the action of historical forces. The insolent, often monstrous brutality of his works during the 1930s was a warning of tragic feelings and terrifying events.

At that time he lived more or less alone. Unexpected financial difficulties obliged him to spend 1933 in Spain, staying with his mother in Barcelona for a few months. The year before, he had designed the costumes and decor for the ballet *Jeux d'enfants* staged by Léonide Massine at Monte Carlo, with music by Georges Bizet and scenario by Boris Kochno. Miró's progress towards abstraction became accentuated, and his search for expression became more intense and dramatic, with the exception of a few joyful intervals. In the autumn of 1936 he returned to Paris, and lived through the tragedy of Spain, just as he did that of World War II later, in complete isolation. He did not allow his inner torment to show except in his paintings. For the 1937 Paris Universal Exhibition he painted a vast panel for the Spanish Government pavilion. He lived in a flat in the Boulevard Blanqui, then later moved to the Boulevard Garibaldi; in 1938 he began to take his family to visit Varengeville, on the Normandy coast, where

Braque had a studio and country villa. At first a guest of the architect Paul Nelson, for whom he completed a mural painting, he afterwards rented Le Clos des Sansonnets, where he remained from August 1939 until the following May, when he returned to Paris because of the Nazi advance, and subsequently left in haste for Majorca.

At Varengeville he was absorbed in a sort of meditative retreat by which he escaped the horrors of the catastrophe that was invading Europe. ' I felt a deep desire to escape. I deliberately shut myself up within myself. The night, music and the stars began to assume a prime importance in the motivation of my paintings.' So his silence, as far as the war was concerned, was not just indifference: it stemmed from a desire to oppose it with the universality of art, of the inner life. He was fully conscious of the dangers which threatened. He stated, in 1939; ' let the powers of darkness known by the name of Fascism extend further, or thrust us any deeper into the blind alley of cruelty and lack of understanding, and that will be the end of human dignity.'

In the quiet of Varengeville, he had begun a series of gouaches entitled *Constellations*, dating from January 1940 to September 1941, which were finished at Palma and Montroig, and which constitute one of the most successful creations in his artistic experience. These were shown by Pierre Matisse in New York in 1945, where a major retrospective exhibition had taken place four years earlier, prepared by James Johnson Sweeney and received with enthusiastic success. Miró returned to Barcelona in 1942, and, while living in the Calle Folgarolas, he started work in the studio he kept in the Pasaje del Credito, in his mother's house. He worked with a passionate intensity, showing himself richer than ever in inventiveness and formal certainty. From this period of concentrated labour there emerged a series of magnificent works of fantasy in which spacial effects and linear drawing combine in structures which combine great spontaneity with assurance and decisiveness.

Thereafter Miró's way of life suited him perfectly. In 1944 he began to create in pottery with his old friend Artigas.

In 1947 he spent eight months in New York, where he prepared a huge mural painting for the restaurant of the Terrace Hilton Hotel in Cincinnati, Ohio. In 1948, after eight years of absence, he returned to Paris. Almost immediately he contracted with the printer Mourlot to embark on a series of wonderful lithographs to which he devoted himself, together with engraving and pottery.

He settled permanently in Barcelona, in the Calle Folgarolas, leaving his former studio in the Pasaje del Credito, where his mother had died in 1944. In 1951 he executed a mural painting for the refectory of the Harvard Graduate School; this work has since been transferred to the Fogg Art Museum. In 1954 he was awarded the first prize for painting at the Venice Biennale. In 1956 he moved into the house which his architect friend José Luis Sert, one of the designers of the 1937 Spanish Pavilion in Paris, has designed for him on a hilltop in Palma de Mallorca. He was now world famous. In 1958 he completed two imposing ceramic murals for the Paris headquarters of UNESCO; in 1959, the year in which he returned to painting after a four-year break, he went to New York, where President Dwight D. Eisenhower presented him with the Guggenheim Foundation's International Prize, and the Museum of Modern Art once again devoted a retrospective exhibition to him. He visited New York once more in 1961.

As far as externals were concerned, his life was now one of uninterrupted success and acclaim. It seems hardly worth recording any further events; as we said at the start, he lives his life deep within himself, and for that reason it is very different from a life made attractive by escapades or strange vicissitudes. His truest adventure has been confined to his works, as usually happens to artists who control and dominate external forces by means of an inner ideal, asserting their freedom by moving forward into uncharted artistic territory.

Works

In the middle of the nineteenth century, artists turned from recording the objects which appear in the physical world, to explore the structure of appearances. The products of this essentially analytical process, arranged in a harmonious structure, formed a new synthesis. The process consisted in discovering in the perceptual field the technical and aesthetic means appropriate to the expression of a personal vision. At the same time as artists became concerned with probing the structure of this reality, and thus isolating its formative elements, they were also seeking to acquire new possibilities of expression, investigating how new formal elements could be effectively used to convey meaning, through discursive processes which would transcend conventionalized and codified perceptions. At first their work amounted to a lyrical reconstruction of the physical world, eschewing any idealization of reality or personification of emotion, and faithful to the spatial syntax of Renaissance tradition. This is the case with the impressionists. The fauves, on the other hand, aimed at essentiality, and founded their representation more on expression than on the senses. The cubists who followed them rejected any consideration of emotion or of sensory impulses, employing an intellectual method to arrive at a definition of autonomous plastic values.

The development of contemporary artistic creation began at this point, the point at which art no longer sought metaphorical transformations of sensory reality; it now set out to create structures whose effect was purely aesthetic. Its goal was now the autonomous object, the ' thing in itself '.

This new investigation of the visible world did not only provide an objective framework; it brought to light certain phenomena of a different nature. Modern art has concerned itself with the world of dreams and the subconscious, which Sigmund Freud studied. The ' invisible ', which art makes visible, consists in this case not of the structure of empirical reality but of something which has no relation to

it. To look behind the façade, and to bring to light movements and figures submerged in the obscure remoteness of the subconscious, reveals another human reality, one of subconscious activity, of nightmares and anguish, which, again, is incompatible with that which is already known and classified. At the same time, expressive associations were extracted from apparently random associations of ideas. Already cubist theory had represented relations between objects; while still following a diagram of forces suggested by reality, it had finally deduced from it a plastic structure which did away with nominalism. In surrealist art, relations between objects were purely arbitrary, temporary, surprising, but embedded in an absolute plastic context, just as the cubists had ultimately sought a figurative and not introspective truth; they were concerned with investigating the psychological process of visual perception. In dreams, things and events have perfectly real outlines, and the surrealists therefore transcribed them in realistic terms for that reason.

The short-lived Dada movement, an explosion of artistic nihilism, had freed the creative gesture from rational limitations and rules; surrealist art, on the other hand, while remaining disordered and strange, tended to rationalize the irrational, to give it a plausible arrangement and everyday language. It employed a clash of incompatible but real and definable elements, and thus retained, in contrast with the goal of the cubists, a literary flavour. It constituted a radical artistic revolt against the positivism of all those movements, ranging from cubism and constructivism to the technological didacticism of the Bauhaus, which had shown themselves to be aiming at a rational organization of objective reality. It set out to combat technological and collectivist ideas and to maintain the primacy of the individual, to rehabilitate, though perhaps with a different aim, the literary and metaphorical sources of artistic inspiration which existed prior to Courbet.

For that reason the surrealists were mistaken when they proposed to associate their aesthetic revolt with the revolutionary principles of Communism. Their political and social aspirations were inevitably a failure, because their indivi-

dualism and subjectivity were incompatible with the universal peace and harmony which was their declared goal. Surrealist thought still involves, in the last instance, the interpretation of images. It contains a message, which the spectator's mind must discover, but which is ambiguous and enigmatic, because it stems from private feelings and states of mind. The individual's inner life, when considered in isolation, cannot attain a true general significance because the 'inner monologue' remains inaccessible. Dream and reality are elements which naturally cancel each other out, and any attempt to fuse them produces visionary and utopian formulations.

In other respects, the limitations of surrealist practice are demonstrated by the fact that it never created a proper stylistic system. In as much as it proposed a certain tendency, it remained indifferent to forming an expressive language, and for that reason it habitually employed the most varied expressive styles that exist in our culture. Even its style of representation was consistently absurd: in order to represent 'surreal' events it borrowed formulas of the most banal realism. For that reason its adepts, aside from revealing themselves as a group of skilled eclectic virtuosi, faithful to doctrinaire programmes, were very successful in creating illusionist scenic fantasies. Surrealist thought, obstinately determined to transcend all cultural conditioning, succumbed in the end. Nothing can be created in isolation from a cultural context: and, if art is to be renewed, it is not sufficient to denigrate and reject contemporary culture; it must be regenerated in its essence.

What has been said up to now has been intended to provide a context for the discussion of certain people who, working in this way, achieved artistic success. Surrealism has its own talents: those who, injected into this tide of poetry and thought, represent the purest expression. Although in the end they might find themselves in a marginal position, certain surrealists have expressed themselves in original and meaningful formal systems, besides relating them to certain patterns that have progressively come to dominate the aesthetic field. Jean Arp, Max Ernst and Joan Miró occupy an unquestionable position of the first order in the

history of art, and their intellect is really measured by the effectiveness of their language, which is not cultivated or acquired but mobilized and organized by expounding their own concepts, and not from the data provided by existing conventions.

Miró's beginnings certainly showed nothing exceptional. On the one hand he practised drawing, depicting the aspects of nature in fluent draughtsmanship and curves, not without some reminders of Art Nouveau, nevertheless livelier than the latter and less decorative. On the other hand, while rejecting the academic teaching of the art schools, he still attended them, as if he wished to submit himself, however briefly, to their discipline. His artistic vocation came to fruition of its own accord, as happens with the most talented, without any other support than that which he obtained by means of his own personal choice. Attending ordinary art schools leads on the whole to subjection to standardized rules, to immutable and codified examples, an array of fragmentary and heterogenous data, confused and therefore obscure. The student comes into contact with a false and arbitrary culture, while being kept away from active life, as if from a contagious disease. True creativity, on the contrary, constantly relates past examples to present experience, just as it selects those things in the present which will go to make up history. The artist, when he really is one, gives effect to a fervent desire to act in one direction, and, in the process, brings various inherited reserves into play. His behaviour is never that of someone who follows a certain pattern of ideas, however practical, but that of someone who acts as a guide. In this sense, reality is a better teacher than any scholastic lesson, and the only academic skills required are those which are relevant to the present. From the first, Miró asserted the authority of his artistic nature by paying attention to the uncontaminated teaching of sensory truth, and by listening to his immediate predecessors. The sinuous fluency of certain of his youthful drawings clearly reveals unconscious memories. On the other hand, suggestions taken from Cézanne, van Gogh or Matisse are due to a clear understanding of their work, gained at the age of twenty. If Miró wanted to assume a place in history

to interpose himself with his own authority, he could only take contemporary influences as his starting-point. New work at that time was either divisionist (pointillist), fauve or cubist. Miró felt encouraged, yet, without becoming a slavish imitator or a fanatical proselyte, he used those traits that best corresponded to his personality at that moment. The attention he had paid to nature had induced a certain descriptive care in him, while drawing practice had given him considerable skill in draughtsmanship. His recourse to Art Nouveau led directly to contact with Japanese art, at that time held in high esteem, while the use of detailed representation sent him back to *le Douanier*, Henri Rousseau, whose fantasy and dream-like weirdness some of his own later work was to recapture. Then perhaps this particular feeling for magic was not immediate; it was still hardly detectable at the time of his first one-man show at the Dalmau gallery in 1918. To find oneself takes time, and requires a succession of discards, a gradual reduction in the data at one's disposal, and one can only really test its expressive effectiveness in the direction one intends to follow.

However, from the start, there appeared an element which was to assume a central place in Miró's creative development: draughtsmanship. A painting by Miró is a latticework of lines, a surface with incised profiles: his forms are silhouettes deepened by tonal colours. Over the years, this graphic foundation evolved into a handwriting. In the early years it had violent outlines, recalling the fauves and Gauguin. *The Path, Ciurana* from 1917 (*pl. 9*) is decorative, with curves and sharpened points roughly divided by bands of colour. A true geometric fauvism, which, in *North-South* (*pl. 10*), remains more faithful to his original principles, is organized in a narrower progression in *Vines and Olive Trees, Montroig* (*pl. 15*), dating from 1919, where, however, in the background, there is a strange, discordant, diffuse light of naturalistic origin. Background and foreground still remain clearly separated in *The Farm* (1921-2), but no longer with naturalistic echoes (*pl. 18*). The reduction of empirical data is almost complete; even the theme is presented with a kind of simplified realism

15

as the sum total of many subtle details which spontaneously draw and hold the eye because they are indivisible from the whole. One could say this is more or less what happens in all Miró's paintings: they are valid and genuine compositions in the traditional sense.

Each work has a coherence capable of expressing a general harmony and mood, with equal ease whether it is quiescent or quickly flowing. Nevertheless, after appreciating organic unity, the eye begins to see those fragments which compose and sustain it; the same richness of individual details, enhanced by smooth and rhythmic juxtaposition, that occurs in the compositions of the great painters of the past. This does not happen, for example, in many of the cubist paintings or those of other movements, where our regard is unable to leave the whole, since their elements coexist spatially and temporally in an insoluble manner. But in Miró there is a concord of details and overall structure in such a way as to achieve the persistence of active elements within an organized system.

A similar appeal to certain emblems – the persistent detail is anything but a banal irrelevancy – is still encountered in later works in which the emblems reappear in non-representational form. The *Constellations* and other figures invite us to observe them for themselves, not because they are whimsically or eccentrically primitive, but because they are pure figuration, and thus possess an almost magical energy, as images, which one cannot ignore. Miró's forms, whenever their empirical matrix is concealed, are always biomorphic, as with Arp or Klee, and lose the plastic clarity they still retain in *Douanier* Rousseau's vision. Rousseau always pictures three-dimensional objects, which are distinguishable by their likeness. Miró has not remarked on this, and I mention Rousseau solely as a term of comparison apt to clarify the meaning of certain solutions. However, one cennot deny that Miró uses what might be called hyper-realistic formulae which resemble those used by Rousseau.

Miró's novelty and audaciousness consist in his paring down of the natural object until he creates a typical sign in which name and attribute, sensation and consciousness, become

identified: the point at which there is no place for evasion or vagueness. The effect lies wholly in overcoming the resistance of things in order to transform them into meaningful signs. In Miró's paintings dating from 1917 the sign is still expressionist, scarcely personalized; his expression is still committed to a statement in a current language, characterized by a certain violence which is not found at a later date, except in some of his 1937 compositions, for example *Still-life with old shoe (pl. 40)*. Here it appears that the impression received in 1928 from the Dutch painters of the seventeenth century has an explicit correspondence in the sinuosity of the forms no less than in the influence of the powerful encounter of light kindled by vivid colours. However, a similar virulence can be discovered in the *Spanish card game*, which dates from 1920, and which, through a certain attitude learnt from cubist models, shares in the same dramatic act. Any borrowed element in Miró is infused with his own originality. The richness and therefore the interest of an artist resides partly in this conflict between contributions, which ultimately ends in a synthesis characterizing the personality as a creative entity.

To return to the essential role of the graphic sign in Miró: in *The Farm (pl. 18)*, a harmonious texture is completed by means of strokes and cross-hatching, of segments of curves and straight lines, all linked by the thread which guides the artist's vision as well as the viewer's discovery. The calligraphy of leaves and branches, the scenographic frame for the chicken-house, and the divisions between cultivated fields, form a complex which is alive with tiny episodes – the newspaper fragment juxtaposed in the centre with a watering-can is another reminder of cubist concepts, but by no means a random or extemporaneous one. All the lines and all the forms respond to one another in a structural manner, as in a mesh of different colours and materials. The same excitement, even though less powerful or impressive, manifests itself in *Vegetable garden with donkey* and *Palm tree*, dating from 1918, and *Vines and olive trees, Montroig (pl. 15)* and *The Village at Montroig (pl. 17)* from the following year. A vocabulary of summary

graphic signs, of tangled and enigmatic threads, functions in the last resort as a meaningful connection, just as in the natural universe the macrocosm is acted upon by micro-organisms which lie on the borderline between vegetable and animal. Certainly Miró uses the image to the point where there is no distinction between empirical and created reality, so that the latter is superimposed over the former. It is not a matter of achieving an unstable neutrality; on the contrary, his aim is to carry into effect a stylistic idio-syncrasy which overcomes all the difficulties of a shared vocabulary. Miró's stylistic imprint could have its origins only in such a graphic tendency. His own personal icono-graphy, his biomorphic linearity, like a thread moving along a subtle line from form to form, collects diverse focal centres by attraction, linking one with another while itself floating free in the calm of the limpid space, as if the forms were strange kites held by invisible hands, or as if the line itself skimmed the surface of mysterious, invisible solids or voids.

This is the reason for the feeling of mobile suspension which predominates in his painting, and that appearance of lines which are not incised but emerge as if from sandy soil. This graphic arrangement still survives in certain more important paintings, as for example *Ear of grain, The Carbide Lamp* and *Grill and carbide lamp*, dating from 1922-3; on the other hand, in *Horse, pipe and red flower* and *Still-life with rabbit*, both dating from at least two years earlier, the graphic line becomes assimilated in a composite texture in which a representational exuberance is still reflected, exploiting intersections and facets of a cubist stamp, a multiplicity of fleeting perspectives, agitated but carefully controlled, in which he attempts to remedy orthodox cubism's schematicism, without repudiating its structural usefulness.

However individual an artist may be, he cannot be a hermit; his work exists in the context of the times in which he lives. The important thing is to produce antibodies within oneself to avoid any risk of contagion. It can happen that certain models are interpreted in a sense different from that proposed or promised, and that a situation of

historically evolving perspective must in some measure involve brief deviations in the course of which the artist may encounter obstacles or correctives. Indeed, like nature, history and art never advance in jumps; they always return to the mainstream of evolution, despite delays and setbacks. The cubist venture not only caused a change in the whole face of art, but also gave a number of dialectic possibilities to artists who did not feel able to share its definitions or its concrete conclusions. In 1919 Miró was influenced by the cubists. Self-portraits, *Seated nude (pl. 16)* and certain still-lifes bear clear signs of this; that is to say, they reveal the use of cubist technique, but the meaning is different. Miró's imaginative vitality is so intense that in the end he succeeds in minimizing, where he does not fully suppress, dependence or reproduction. His ultimate decision was firm. From the early 1920s onwards his verdict on the cubists was expressed in the phrase: ' I'll break their guitar! '

Miró's independence from certain contemporary conventions is even more evident in his confrontation with the surrealist experience, of which he was far more prepared to welcome the methods and suggestions.

In the work of a Salvador Dalí or a René Magritte, the power of fantasy is replaced by illusionist formalism. In dreams, objects appear in the most concrete and plastic detail, and for that reason they are reproduced in the paintings of these artists with the most fluent and true-to-life precision; the feeling of strangeness is aroused solely by means of unaccustomed juxtapositions, abnormal figures and other-worldly lighting. By contrast, in the work of André Masson, Max Ernst and Jean Arp, imaginative expression is entrusted to an entirely original formal language, conceived in terms of the effects desired by the painter. Miró instinctively eliminated the improvisatory, even ' automatic ' nature of surrealist practice, and eschewed the literary manner of Dalí and Magritte. But, what are those threads, in *The Village of Montroig (pl. 17)*, which rise sinuously up two thirds of the canvas from the right corner? And what is that number 173 in the left foreground? Certainly a fascinating painting, yet strangely

19

incongruous: a foreground of geometric stylization, a middle ground of realistic stylization, a background which is almost punctiliously descriptive. *The Tilled Field* of 1923-4 (*pl. 20*), which is related to *The Farm* (*pl. 18*), represents Miró's mastery of this art of concentrating moments of inspiration in one unified texture, where all the details, the signs which were soon to become increasingly familiar, behave in an organic fashion.

Nevertheless it was *Harlequin's Carnival,* dating from 1924-5 (*pl. 23*) which gave the most persuasive measure of the personal style which Miró henceforth set out to develop, in order to redeem himself from the ambiguities and influences which had remained so insidiously harboured in his work. It forms a joyous unity, in which all his figures meet, sometimes stylized, sometimes completely abstract, wild and straggling, but always linked together in the same lively, fantastic animation.

On close examination, Miró can be seen to indulge in decorative arabesques, just as the burlesque poses of his figures conceal an undercurrent of wistfulness. Toys in the hands of adults always testify to nostalgic feeling, and in his studio in the Rue Blomet several toys were placed where they could be clearly seen, some from the Balearics in painted plaster, some from his own native district; he always kept these with him. Other influences stem from the mural paintings of the tenth or eleventh century that are to be found in Catalonia. But he never allows himself to be attracted by the coy clichés of folklore. His exuberance springs from a vivacious temperament, on the same level as that of his compatriot Antoni Gaudí, and certain mannerisms can be ascribed to the spontaneous endorsement he wished to give to certain solutions he had discovered. It appears that Matisse, too, had made a more than momentary impression on him, not only in a certain chromatic vividness but also in the use of background scenery of soft furnishings or else flowered tapestry.

In discussing all these influences, however, we are dealing with momentary phases, quickly outgrown, just as the angles and facets borrowed from cubist practice were only subsidiary, and just as the pointillism which can be detected

on the edges of the grounds was merely a reflection of a transitory interest on the artist's part.

One can, without any difficulty, catch glimpses of representational methods typical of Picasso, Braque, Gris and Léger in Miró's paintings up to the mid-1920s, but there is no longer the feeling that he is following them on principle; he is seeking to try out their discipline, or perhaps to measure himself against them. Any artistic precedent which can be detected in Miró's work is no more than an incident on the road to total independence and technical mastery. Oriental art attracted him, and he called the Chinese the ' great lords of the mind '; but although this was a time in which there was a widespread interest in Chinese art, this left hardly any detectable traces in his works. At heart, Miró, just as he was not inclined to delirious imaginary visions, was wary of external artistic influences, however useful or effective they might seem. In his work, he forges the union of the universe of things and the figurative universe, ideals and poetry, which nevertheless maintain their own prerogatives and observe a reciprocal respect and restraint.

Even at this stage in his development, one thing had already become absolutely clear. Miró was never to attain Klee's dramatic tension or Mondrian's absolute order. The world he represented appears by comparison less predetermined, restlessly moving between oscillating alternatives. Jacques Lassaigne has described the Miró universe in a few words: ' In this indeterminate space, heaven or hell, there suddenly stands out the precise flight of a star, the track of a comet, the fall of a rocket. '

Harlequin's Carnival (pl. 23) constitutes a new departure in Miró's painting; its vivacious, almost choreographic action, almost too rich in details, all joy and lightness, marks the beginning of the artist's maturity. Henceforth his terms and his themes are clearly defined. The change is truly remarkable: the descriptive minutiae lose ground with the lessening of his compositional formalism, and Miró's art emancipates itself from realistic objectivity. The *Birth of the World* (1925), in the René Gaffe collection, has no verisimilitude; and *Maternity (pl. 21)*, of the year before,

is framed in an arrangement of consonances within an aerial space where they can oscillate freely.

And this period, so full of discovery, the period of the poem-paintings, is another step towards a lyricism of signs. The texts can be interpreted as the persistence of significant factors which have not yet been isolated from their concrete aspect; they fulfil the same function as the realistic elements in Miró's preceding works. Miró cannot dispense with semantic references: the sense of the marvellous which he seeks to transmit rests on supports which he leaves visible, as if he wished to guarantee the truth of the discourse; hence it is never abstract in a pure sense. Symbols, meta-morphoses, analogies, allusions, are all rhetorical figures of which he makes great use to reveal non-physical situa-tions, or further possible utilizations of data detached from the phenomenal reality containing it. His intentions are ' to rediscover the religious and magic sense in things, which is that of primitive peoples ', persuaded as he is that ' every grain of dust possesses a marvellous soul.' Here, then, the scene of his representation is simplified and becomes all the more empty, spatially clear of accessories; the perfor-mance involves few figures. Among the most notable examples of this period is *Dog barking at the moon*, 1926 (*pl. 29*), a proof of his consistent adherence to the linea-ments of truth.

Miró has always devoted himself to a revival of mythical feeling. Ultimately mythology is a kind of challenge to all that has not been explained in real terms and thus lends itself to interpretation as supernatural. However, it is improbable that, in our day and age, any event, whether natural or not, could be considered as separate from the known world. It follows that universality is no longer restricted to those things we call mysterious or miraculous, works of occult or unproven power before which one must kneel with propitiatory servitude, but resides in the aesthetic impulses generated by any event or object which we can perceive. Miró always returned to primary sources, listening for whatever pulses deep down in man, and finding an apt sign for all the data thus intercepted. It was in this way that he created the highest achievements of his artistic

career, beginning in the 1930s, when so many stars, comets and constellations drifted through his paintings. His morphological signs were born step by step, progressively absorbing their symbolic aspect.

In 1925 he still remained uncertain, as two *Heads* prove, one (*Head of smoker*, Roland Penrose collection) still identifiable and the other (*Head of Catalan peasant*, Bonnier collection) completely taken apart, the subject barely recognized by the cap, itself a formal mark on the sparkling blue background, which also contains other attributes and metaphors. The constant longing in Miró to reduce reality to essential, even abnormal, even minimal forms, which stimulate a dream state or else refer to transcendentals accepted because they are revealing, is clearly expressed in the *Imaginary Portraits* and *Dutch Interiors* dating from the second half of the 1920s. His journey to Holland took place in 1928; and although we know that Vermeer impressed him greatly, the fantastic versions he completed of Dutch paintings relate to minor artists like Steen and Sorgh. In the *Imaginary Portraits*, too, originals by Raphael and Constable contract into a kind of phantom iconography. However convincing and effective the result on an aesthetic level, one cannot ignore that this stems from a purpose of negation. And in point of fact we are on the threshold of the phase in Miró's career in which he was affected by the spirit of Dada, and wholly engaged in questioning his own painting before that of anyone else. What at first was a humorous attractiveness was replaced by a kind of caustic reserve; and what had formerly been concise and graceful arabesque now represented an ominous uncertainty.

The simplifying process, which had always been at the basis of Miró's creation, is here carried even further, and if the severity with which it is pursued minimizes the poetic response, this is compensated for by the expressive force of the formal contrasts. Even his technical researches: collages, object-paintings, paintings on wood, copper, masonite, sandpaper and so on, which continued right through the 1930s, were no longer ephemeral experiments, because they possessed a sober, decisive energy, such as endows the inventive act with a note of startling and persuasive truth.

23

The point of greatest dramatic violence came in *Still-life with old shoe* of 1937 (*pl. 40*), in which an almost brutal formal vigour is intensified by a blaze of light. Miró was overwhelmed by the horror of the Civil War; his inner balance was shaken. Meanwhile, deprived of his own studio, he frequented La Grande Chaumière, mingled with the young students, made drawings from life full of violent distortions of a kind which had hitherto been unusual in his work, and which could only be a mark of an otherwise inescapable torment. The testimony of this time which reflected Miró's more enduring character was *The Reaper*, a mural (now lost) painted in oil on celotex for the Spanish Republic pavilion at the 1937 Paris Universal Exhibition. This was a counterpart to Picasso's *Guernica*, and illustrated the differences which separate their two personalities.

Miró did not take long to recover from the serious disturbances which had distressed him. He retired to Varengeville, on the Normandy coast near Dieppe, and there he concentrated on thought, carrying out a series of works which are among his most important in purity and effectiveness of expression. He continued this series with the same expressive intensity and dynamic quality at Palma de Mallorca, where he fled after the fall of France in May 1940.

The cycle of *Constellations*, most of which were painted between 20 January 1940 and 12 September 1941, are the products of a period of absolute retirement. ' I deliberately shut myself up within myself,' Miró confessed in 1948. Women, birds, and stars populate the canvas in a sequence of cadences, once again in a dazzling progress, shining here and there with vivid colours, all unexpected, but not less effective (*pls 45-7*). The backgrounds suggest a vast, vibrant space, the faint dark light with its faint chromatic mists has an almost interstellar air. The order in which the multitudes of figures incessantly move, in a tangle of meetings and separations, appears to obey a planetary gravitation. The sense of movement is imparted by separate bodies which unite in the course of their more or less orbital trajectory. Thus Miró formed his own cosmology and was to remain faithful to it, the same restless stars being immediately recognizable in future works.

Having brought his own universe into existence, up to 1944 Miró worked only on paper, with great application but not frenziedly, demonstrating how his stellar visions form a magnificent, organic and continuous cosmic spectacle. When he began painting on canvas once more, he did so with inexhaustible inventiveness, employing the most varied technical means. At first the process of simplification led to the supremacy of the draughtsmanship, the pictorial images being mainly fixed in linear outlines; but, from 1949 on, the compositions became more condensed, the gestures more fiery. Avoiding hesitation in the sense that this involves compositional calculation, Miró became far more decisive, and thus avoided the preciosity which had been present whenever he succumbed to the temptation to indulge his linear agility for its own sake. Now on the contrary, his figures became characters in their own right, their stern looks and harsh demeanour delivering a serious admonition. Certain of Klee's images reflect a similar elemental seriousness. Miró was never again to contemplate fantastic firmaments of the kind which appear in the *Constellations*; he now became involved with menacing phantasms, painted with disconcerting agressivity. The signs had grown bigger, black was emphasized in heavy strokes, colours flared up like a conflagration. Behind this we find the same Miró, remaining in relation with nature, where powers clash, where grief and gaiety, storm and calm, eternally alternate. The light which the colours transmit, however ambiguous it may be, is not exempt from a vague flicker of hope and delight.

In 1944 he had meanwhile begun to work in ceramics with Artigas. In 1947 he completed an imposing mural painting for a hotel in Cincinnati, and in 1950 another for Harvard University. In 1957 he made a tiled mural for UNESCO in Paris (*pl. 63*), and in 1960 a further work for Harvard. He devoted himself with interest to lithography and engraving. Thus he had proved himself in all techniques and in all formats. Always sure of himself, he had no need to have recourse to adaptations of any kind which might risk misrepresenting the substance of his conception. He moved without hesitation in the world he had established and did

25

not change the rules by which he governed it. The signs circulate and the colours combine by means of reciprocal attraction. Henceforth he was the owner of a great patrimony, fertile, well tended and wisely worked.

Miró's destiny lay in his faithfulness to himself; his personality was nourished by the direct relation between human feeling and artistic signs. It was constant spontaneity that won him a permanent place in the troubled history of twentieth-century art.

Miró and the Critics

The study by Jacques Dupin, *Joan Miró: Life and Work,* published in France in 1961, and in Germany (DuMont Schauberg, Cologne), Great Britain (Thames and Hudson, London) and the United States (Abrams, New York) in 1962, remains the most complete. It contains an exhaustive bibliography by Bernard Karpel, a catalogue of the oil paintings, and reproductions of many gouaches, pastels and collages. For Miró's graphics, the authority is Sam Hunter (*Joan Miró: his Graphic Work*, New York 1958).

Miró's work has formed the subject of articles in the periodical *Cahiers d'art* almost without a break since 1929. Not until the monograph by James Johnson Sweeney (*Joan Miró,* New York 1941) did a substantial account of the artist exist in book form. Sweeney was followed by Clement Greenberg (*Miró*, New York 1949) and by James Thrall Soby (*Joan Miró*, Garden City, N. Y., 1959). In Europe, useful contributions were made by Juan Eduardo Cirlot (*Joan Miró*, Barcelona 1949), Alejandro Cirici Pellicer (*Miró y la imaginación*, Barcelona 1949), Jacques Prévert and Georges Ribemont-Dessaignes (*Joan Miró*, Paris 1956), Paul Wember (*Miró: das graphische Werk*, Krefeld 1957), Eduard Hüttinger (*Miró*, Berne 1957), Walter Erben (*Joan Miró*, Munich 1959) and Guy Wellen (*Miró*, Paris 1961).

Not included in Karpel's bibliography are later monographs by Yvon Taillandier, Joaquim Gomis and Joan Prats Valles in 1962, by Jacques Lassaigne and Sebastien Gosch in 1963, by Yvonne Bonnefoy in 1964, by Gomis and Prats Valles in 1966 and by Juan Perucho in 1968.

Notes on the Plates

1 The Peasant, 1912. Oil on canvas, 65×50 cm. Paris, Galerie Maeght. One of Miró's earliest known paintings, often exhibited and cited. The problem of dating it has still not been solved. Signed and dated 1912 in the lower left corner, the catalogue of the 1962 exhibition at the Paris Musée d'Art Moderne inexplicably declared it to be '*Signé et daté en bas à gauche: Miró 1914*'. The catalogue for the exhibition held in 1964, first at the Tate Gallery in London, later at the Zurich Kunsthaus, specifies the inscription as doubtful by having another indication follow the title: ' 1912(?)-1914 '. 1912 is the most likely date for the execution of the painting, at least from the stylistic point of view. In 1912 Miró was attending Galí's Escola d'Art in Barcelona, and showed an unusual but still raw chromatic exuberance. This is certainly revealed in the painting, as well as an ardour which reveals the influence of the fauves and van Gogh.

2 The Clock and the Lantern, 1915. Oil on card, 52×64.5 cm. Lausanne, J. Didisheim collection. This painting exemplifies the experiments with which Miró was struggling in his attempts to reconcile Cézanne's constructivist sense and van Gogh's expressive violence.

3 The Coffee Pot, 1915. Oil on card, 50×55 cm. Paris, Galerie Maeght. In James Thrall Soby's opinion the date ought to be changed to 1916. This view is supported by signs of a greater knowledge of colour, and a greater confidence in the composition, than in most of Miró's 1915 paintings.

4-5 The Village, Montroig, 1916. Oil on card, 60×69 cm. New York, Pierre Matisse Gallery. Still imbued with respect for the natural vision, here we feel a Cézannian slenderness in the constructive relief given to the terracing of the houses. Of special interest is the sky, animated with brightly coloured dots.

6-7 The Blue Bottle, 1916. Oil on card, 57×68 cm. Paris, Galerie Maeght. A rather rigid compositional geometry; the colour could be compared with that of the fauves. Similar deformations are to be found in other still-lifes of the period, which employ almost the same subject.

8-9 The Path, Ciurana, 1917. Oil on canvas, 60×73 cm. Paris, Ernest Tappenbeck collection. Miró has drawn a truly singular painting of this ancient Tarragonese village. Still in his fauve pe-

riod, Miró's geometric emphasis has become more decided, and has acquired rhythmic power of notable effectiveness. The red flowers in a field in the foreground are worth noting; in them Miró uses a similar treatment to the dots set in the sky of the 1916 Montroig landscape (*pls 4-5*).

10 North-South, 1917. Oil on canvas, 62×70 cm. Paris, Galerie Maeght. Perhaps the work closest to the fauve model that Miró ever painted. Chromatically pleasing and compositionally of vivid skill, it only partly reveals the problems that occupied his mind at the time. Following cubist practice, he inserted words into the painting. *Nord-Sud* was the title of the review edited by Pierre Reverdy.

11 Standing nude, 1918. Oil on canvas, 152×122 cm. New York, Pierre Matisse Gallery. Between 1917 and 1918 Miró carried out a series of portraits in which echoes of the cubists and fauves are combined with expressionist aggressiveness. This nude – also known as *The Odalisque* – reveals an equally dramatic violence, which is cancelled out by the overpowering scenic richness.

12-13 Wheat threshing, 1918. Oil on card, 45×56 cm. Paris, Galerie Maeght. The attachment Miró feels for nature, which inspires in him powerful, even tumultuous emotions generally combined with tenderness, is well expressed in this painting, even in its slightly hurried succinctness.

14 The Trail, 1918. Oil on canvas, 75×75 cm. New York, Mr & Mrs Gustav Stern collection. This painting is considered as one of the precursors of a period rich in notable examples, in which, having discharged his debt to the fauves and cubists, Miró concentrated his own feeling for the marvellous in nature in a small-scale, lyrical descriptiveness. This is what might be termed his calligraphic period, so precise is it in richness of detail.

15 Vines and olive trees, Montroig, 1919. Oil on canvas, 72×90 cm. Chicago, Ill., Mr & Mrs Leigh B. Block collection. Examples of this calligraphic phase, as well as the preceding painting, are *House with palm tree* and *Kitchen garden with donkey* in 1918. It also produced his best works of 1919, reaching its culminating point in *The Farm* a few years later. But here the excessively realist accuracy disappears and a rhythm is set up which encompasses all the pictorial forms; these, as natural elements, function in an autonomous manner. A discordance between the naturalistic softness of the horizon and the gradation of the mountains reminds Jacques Dupin of Chinese painting.

16 Seated nude, 1919. Oil on canvas, 112×102 cm. New York, Mr & Mrs Pierre Matisse Collection. By comparison with *Stand-*

ing nude of 1918 (*pl. 11*), this figure is distinguished by a more sober composition and by a less brutal realism. Greater discipline has guided the artist's hand, and has refined the shape of the body as well as the designs on the carpet and the small chair. The explicit use of cubist mannerisms of style does not ultimately spoil the austere and mysterious, even subtly erotic monumentality of the figure.

17 The Village of Montroig, 1919. Oil on canvas, 73×61 cm. Palma de Mallorca, Miró de Fernández collection. Painted on his return from his first visit to Paris, this canvas still shows the descriptive manner which his friend Rafols called *detallista*. It is also remarkable for the vertical succession of its various perspective levels and the impression of compressed unity which is conveyed despite the different means by which the grounds are worked out. In it, a sort of geometric abstraction moves progressively towards realistic detail, and ends in a sky which is almost Romantic in its grace, with its clusters of small white clouds.

18 The Farm, 1921-22. Oil on canvas, 132×147 cm. New York, Mrs Ernest Hemingway collection. Miró's first Paris show, organized by Dalmau at the Galerie La Licorne, with a catalogue by Maurice Reynal, was a failure. Miró returned to Montroig and began this canvas, which he continued at Barcelona and completed in Paris. It depicts the family property at Montroig. Some years later, it was bought by the American poet Evan Shipman on behalf of Ernest Hemingway, who declared he would not have exchanged it for any other painting in the world. It is without a doubt one of Miró's principal works, because it summarizes and completes a cycle of his experience, and because its warmth of feeling fuses symbol and reality, realism and abstraction. All this finely inventoried reality has the hallucinatory quality of a vision.

19 The Farmer's Wife, 1922-3. Oil on canvas, 81×65 cm. New York, Mrs Marcel Duchamp collection. This strange combination of realistic stylization and abstractive fantasy is ultimately a kind of truce in an irreconcilable conflict. Certain simplifications (the stove) assume the form of symbols; certain deformations (the feet) take on an expressionist nature; while the cat's dish is pure abstraction. Reality and fantasy, love and scorn, joyfulness and sadness, are terms which continue to clash in Miró's work.

20 The Tilled Field, 1923-4. Oil on canvas, 66×94 cm. Radnor, Pa., Mr & Mrs Henry Clifford Collection. By this time Miró was in contact with the Dada and surrealist groups. His friendship with Masson dated from 1922, as did his relations with Leiris, Limbour, Artaud, Desnos, Salacrou, and, some while later, Prévert.

21 Maternity, 1924. Oil on canvas, 91×74 cm. London, Roland Penrose collection. This painting marks the beginning of a maturity which was to prove extremely fertile and successful.

22-23 Harlequin's Carnival, 1924-5. Oil on canvas, 66×93 cm. Buffalo, N. Y., Albright-Knox Art Gallery. One of Miró's most famous paintings; he wrote a piece about it in *Verve* magazine in 1938, in which he spoke of the period of hardship that gave rise to the hallucinations recorded here. In my opinion, however, we are dealing with fantasies, rather than hallucinations, in which he transposes familiar figures and objects into extraordinary shapes, in order to stage his phantasmagoric ballet, with its multitude of tiny elements. Here the metaphors are still explicit, the masquerade is still clear, while *The Beautiful Bird revealing the Unknown to a Pair of Lovers* of 1941 (*pl. 46*) no longer contains any lifelike images but has a similar compact rhythm and a similar crowded space.

24 Figure, 1925. Oil on canvas. Private collection. One of the paintings in which the human figure is wholly resolved into symbols. It was painted at much the same time as the series of paintings entitled *Head of Catalan peasant*.

25 Painting, 1925. Oil on canvas, 113×144 cm. Venice, Peggy Guggenheim collection. Another of the canvases in which, as in the preceding examples, everything is simplified to the utmost, and the lines are set out on an animated but ultimately neutral background with dreamlike overtones.

26 Painting, 1925. Oil on canvas, 114×146 cm. Basle, Kunsthaus. Here again spatial tension is achieved by means of lines and figures which intersect across a background of melting forms.

27 Painting, 1925. Oil on canvas, 99×81 cm. Zurich, Kunsthaus (lent by Mlle Widmer). Evocative, enigmatic, abstract, the elements acting in the painting reveal a terse confidence which the hazy surface of the background makes even more enchanting, as always in the works of this period.

28-29 Dog barking at the moon, 1926. Oil on canvas, 73×92 cm. Philadelphia, Museum of Modern Art, A. E. Gallatin collection. Another of Miró's most famous paintings, and among those which demonstrate his desire not to let himself be carried away by his own expressive and visual exuberance. Here the composition is compressed with extraordinary effectiveness, enhanced by the intense beauty of the colours. A clear distinction between sky and earth, composite and bizarre figures, the ladder uniting the two realms, are all factors which frequently reappear, although less

31

recognizably, in later works. According to Dupin, 'The ladder, which is made up of several colours and strongly suggests upward movement, contradicts the severe dividing lines, asserting mankind's power to transcend prohibitions and to build a bridge between animality and the stars ... It symbolizes the power that Miró endows the artist with, of being able to bring two worlds together without abolishing either of them ... It stands for the accession to a higher reality without the sacrifice of familiar reality.'

30 Dutch Interior II, 1928. Oil on canvas, 92×73 cm. Venice, Peggy Guggenheim collection. In the spring of 1928, Miró visited Holland for two weeks and interested himself in the realism of the seventeenth-century genre painters, bringing back to Paris several postcard reproductions which he later used to execute five paintings. The present example was inspired by *The Cat's Dancing Lesson* by Jan Steen, in the Amsterdam Rijksmuseum, and was preceded by a series of studies and designs on the basis of a spatial layout that ultimately reminds one of certain cubist solutions; a certain descriptive desire emerged once more, as well as those dancing movements already marked in *Harlequin's Carnival*. The transformations of the originals are very revealing; one has only to compare them with the attitude Picasso adopts towards famous works, to see that these are less ironic and critical, although also less respectful of the original. Their ultimate allegiance is to a humorous poetry which is particular to Miró. The flat colours and the almost too pleasing arrangement of the forms create a number of apparent spatial anomalies.

31 Queen Louise of Prussia, 1929. Oil on canvas, 81×100 cm. New York, Pierre Matisse Gallery. This is one of the *Imaginary Portraits* Miró painted after the series of *Dutch Interiors*. The painting from which this version is derived has never been identified, nor can Miró remember it. In fact, it was partly prompted by an advertisement for a diesel motor, which by progressive abridgements becomes the figure. On one of the preparatory designs we read; '*très concentré/l'esprit pur/pas de peinture!/mais très riche comme couleur/matière précieuse/très bien peint.*'

32 La Fornarina (after Raphael), 1929. Oil on canvas, 145×114 cm. Paris, Galerie Maeght. Of the other two *Imaginary Portraits*, *Portrait of a Lady in 1820* is from a work by Constable, and *Portrait of Mrs Mills in 1750* by George Engleheart (identified by James Thrall Soby). The Raphael original is in the Palazzo Barberini in Rome. Simplification is carried as far as possible, with the coolest impudence; we should note the truly inexplicable appearance of a fish among the features. This is a surrealist technique, in which surprise is brought about by the juxtaposition of elements which are irreconcilable on a normal level. Its formal profile is

roughly reflected in the *Construction in wood and metal* (1930), in the New York Museum of Modern Art.

33 Painting, 1930. Oil on canvas, 150×230 cm. Paris, Musée National d'Art Moderne. In the turbulent phase which Miró underwent around 1930, his impulses sometimes take on a gay, spontaneous chromatic freedom, as this painting certainly demonstrates.

34 Painting, 1933. Oil on canvas, 130×162 cm. Palma de Mallorca, Señora Pilar Juncosa de Miró collection. By 1928, Miró had already begun to create collages and object-paintings, revealing a need to confirm his expressive resources and to renew them. There are a total of eighteen large canvases, executed between March and June of this year, and all preceded by a collage in which preliminary studies were made by sticking illustrations of machines and various objects dug out of catalogues and newspapers on to card. The resultant forms no longer refer in any way to those grouped in the collage, except in their arrangement. The final work marks one of Miró's highest attainments, in its rhythmic vitality, its chromatic mobility, its spatial breadth, and its subtle sense of an absolute performance, refined and prodigious in its magic.

35 Painting-collage on sandpaper, 1934. Card, 37×24 cm. Philadelphia, Museum of Art, A. E. Gallatin collection.

36-37 Painting on masonite, 1936. Oil, casein, tar, sand on masonite, 78×108 cm. Paris, Galerie Maeght. In the summer of 1934 a more or less suppressed note of anguish found its way into Miró's painting – as in the great pastels called *tableaux sauvages* (wild paintings) – and this became more and more acute until in the autumn of 1935 it reached a crisis which produced an extraordinary series of six paintings in oil on copper and six paintings in tempera on masonite (*see pls 38-9*). These are executed with fury, under the impulse of an uncontrollable anguish, invaded by monsters and by a tempestuous light; their execution is rapid but sure, tortured but expressive. This work is one of twenty-six completed during the summer of 1936, after the outbreak of the Spanish Civil War.

38 Man and woman in front of a pile of excrement, 1935. Oil on copper, 32×25 cm. Palma de Mallorca, Señora Pilar Juncosa de Miró collection. This work is one of a series of small paintings on copper which Miró carried out during the winter of 1935-36, and the catalogue of the 1964 London and Zurich Exhibition cited above gives the exact date of its composition, 5-22 October 1935. The rather terrifying violence of the figures, and the nightmare atmosphere, make this painting one of the principal examples of this phase of Miró's career, and reveal the

expressive energy which is characteristic of it. 'I am a tragic and taciturn person by nature; ... life seems to me absurd,' he was to say twenty years later.

39 Painting on masonite, 1936. Oil, casein, tar, sand on masonite, 78×100 cm. Paris, Galerie Maeght. See note on *pls 36-7*.

40 Still-life with old shoe, 1937. Oil on canvas, 81×116 cm. New Canaan, Conn., private collection. This was painted in Paris, between 24 January and 29 May 1937, in premises owned by the Galerie Pierre. It is one of his most famous works, and James Thrall Soby puts it side by side with Picasso's *Guernica* of the same year in its dramatic impressiveness and emotional content. For the Spanish pavilion at the Universal Exhibition, where Picasso had hung *Guernica*, Miró completed a mural painting entiled *The Reaper*, very different from Picasso's representational fury, but not inferior. Miró had always avoided 'episodic' subjects, and had always kept to his familiar surroundings, and to the most ordinary and modest among them. Thus it happened that a solitary reaper became a symbolic figure of cruel anguish; in the lines and colours which composed it bore all the intolerable weight of a mortal tragedy. But this curse is even more strongly present in this complex, austere still-life, which can really be considered as his *Guernica*.

41 The Circus, 1937. Oil on celotex, 121×91 cm. New York, Pierre Matisse Gallery. The circus horse was a theme to which Miró often devoted himself between 1925 and 1937 and in which he reveals a vivid graphic agility in complete harmony with free imaginative power.

42 Woman's head, 1938. Oil on canvas, 55×46 cm. Los Angeles, Calif., Mr. & Mrs Donald Winston collection. Another of Miró's monstrous figures, and one of his most overpowering.

43 Portrait III, 1938. Oil on canvas, 146×114 cm. Zurich, Kunsthaus.

44 Seated woman I, 1938. Oil on canvas, 162×130 cm. Venice, Peggy Guggenheim collection. Another cruel painting, of imposing expressiveness and sombreness, completed at the end of the year; it bears the date 4 December.

45 The Escape Ladder, 1940. Gouache and oil wash on paper,, 38×46 cm. New York, Mrs George Acheson collection. This is one of the famous *Constellations*, a series of twenty-three small gouaches, faultless in expressive definition and imaginative originality. Clement Greenberg cites this as 'the high point of his art'. This

is the first of the series and bears the date 31 January. It is a fact that this space full of tiny figures and objects, mobilized on formal and chromatic rhythms, appears so natural that we seem to be looking at the earth of a field in spring when it is teeming with grass and as yet unknown insects. Writing in 1923 to his friend Rafols, Miró had spoken of 'monstrous animals and angelic animals', and this description holds good for all his works.

46 The Beautiful Bird revealing the Unknown to a Pair of Lovers, 1941. Gouache and oil wash on paper, 46×38 cm. New York, Museum of Modern Art. On 20 May 1940, Miró had to return to Paris in great haste, then continued on to Spain. The *Constellations*, begun at Varengeville, were completed at Palma de Mallorca and Montroig during the autumn of 1941. The artist, faced with cataclysms, shut himself up within himself.

47 Women in the night, 1945. Oil on canvas, 130×162 cm. Paris, Galerie Maeght. Settled in Barcelona in 1942, he painted on card for two years and in 1944 began to work in ceramics with Artigas; then he turned again to large canvases.

48-49 Bullfight, 1945. Oil on canvas, 114×146 cm. Paris, Musée National d'Art Moderne. The subtle traces which represent the bull and the dead horse have their counterpart in the flat black, red and yellow mass of the bull in the upper right corner, which in turn finds its equivalent in the eyes spread over the left half of the painting.

50 The Red Sun, 1948. Oil on canvas, 76×96 cm. Liège, M. & Mme Graindorge collection.

51 Painting (called Personages in the night), 1949. Oil on canvas, 73×92 cm. Basle, Mme Sacher collection. This expression in the spirit of the *Constellations* has nothing timorous about it. On the contrary, that unexpected and paradoxical sensibility which frequently shows the innocence of children, when they engage in something that is no longer a game, is confirmed here. Graphic and chromatic components work in unison, and everything becomes natural and deprived of malice; a certain self-possessed vividness given to sexual details, reveals that for Miró eroticism was an organic phenomenon of the universe.

52 Inverted personages, 1949. Oil on çanvas, 81×55 cm. Basle, Kunstmuseum. One of the most important of all Miró's works, dated 9 May. Glaring colours, extremely sensitive linear texture, unabashed sinuosity, completed by the organized decisiveness of the whole.

53 Woman in front of the sun, 1949. Oil on canvas, 116×89 cm. Paris, Galerie Maeght. Belonging to a group of paintings known as ' spontaneous ', in which he uses diverse materials and techniques. At this time, Miro worked extemporaneously, almost as if wishing to release an irresistible and uncontrollable impulse which results in a certain degree of automatism. A certain arbitrariness, combined with graphic agility, brings to mind the later creations of the tachists.

54 Woman in front of the sun, 1950. Oil on canvas, 65×50 cm. Another character produced out of the artist's imagination; a certain comic ugliness makes us smile rather than shrink away, as if we were in a familiar presence.

55 Woman, 1950. Bronze, height 31 cm. Paris, Galerie Maeght. Between 1944 and 1950, as Dupin informs us, Miró completed ten true sculptures, all feminine in type. Although never deprived of the artist's own characteristics, they appear less spontaneous than the paintings, and their soundness ultimately appears due to craft skill rather than arising from the imagination. In this way they are very different from the ceramics, which are truly works of absolute fantasy.

56-57 Painting, 1953. Oil on canvas, 120×245 cm. Paris, Galerie Maeght. The thickened line no longer defines the profile of a figure but forms its own: body and limbs, movement and attitudes.

58 The Red Disc in Pursuit of the Lark, 1953. Oil on canvas, 130×97 cm. Paris, Galerie Maeght.

59 The Lovers' Complaint, 1953. Oil on canvas, 46×38 cm. Rome, Galleria d'arte moderna. With respect to the preceding canvas, greater concision is evident as well as a more controlled concurrence of either the imaginative or stylistic relationships.

60 Hair dishevelled by the fleeing constellations, 1954. Oil on canvas, 130×182 cm. Paris, Raoul Lévy collection. This painting bears the date 19 January; the year 1954 saw the beginning of a four-year break in Miró's pictorial production, during which he was taken up with other artistic interests, returning to pottery and engraving. The somewhat restrained mood he always succeeded in eliciting at that time became opaque, and the lines grew summary, as if he had come to dislike his own calligraphy, or was afraid of becoming academic, and sought other ways of communicating his fables, alarming or festive as they are.

61 Woman struggling to attain the unreachable, 1954. Oil on canvas, 69×50 cm. Paris, Galerie Maeght. In this phase Miró began

to give titles to his paintings once more, complex titles that are difficult to interpret. His inner reality gave them to him, and the image-signs he found in this way were considered by him as a clear message, as comprehensible to others as to Miró himself. 'The title is an exact reality for me,' he once said.

62-63 Night, 1957. Ceramic tiles. Paris, UNESCO building. Miró's earliest ceramics with Artigas date from 1944, and ten years later he began to work with him again. Artigas stated that 'without any occupational prejudice, Miró's fantasy had no limits. He was very accomplished technically, avoiding the pitfalls which the freedom of his invention produced at every instant.' It is worth knowing that, according to Dupin, from 25 February 1954 until 10 May 1956 they were able to complete 232 pieces of pottery. To make the two murals for the UNESCO building they had to overcome quite serious technical difficulties, but in the end the result was extremely well suited to the architectural environment.

64 Woman and Bird II/X, 1960. Oil on burlap, 92×60 cm. Paris, Galerie Maeght. Miró, in an interview with Yvon Taillander, maintained that 'since the whole of the human body is of the same nature as an arm, a hand or a foot, eveything ought to be homogeneous in a painting.' Such homogeneity is always an active principle with him, and certainly incorporates those hybrids which are in the end pure magic reality.

65 The Red Disc, 1960. Oil on canvas, 130×165 cm. New York, Mr & Mrs Victor E. Kiam collection. In this period Miró was very close to the experiments of the new generation, who drew considerable instruction from his examples, at the same time as he adopted some of the technical innovations of the young painters.

66-67 Blue II, 1963. Oil on canvas, 270×355 cm. New York, Pierre Matisse Gallery. Here the dark imprints produce an effect that reminds us of the pebbles he used to collect on the beach at Montroig or on Majorca. 'When Miró collects a pebble, it is a Miró,' said his old friend Prats. And Miró reported that for him 'an object is alive', that when he saw a tree, he got a shock, as if it was something that breathed and spoke.

68 Daybreak II, 1964. Saint-Paul, Miró collection.

69 Woman and Bird, 1963. Paris Galerie Maeght. The forms are bathed in a sort of fluid background. The emblematic outlines are intensified by dazzling colour.

70 Daybreak I, 1964. Saint-Paul, Miró collection.

71 Woman and Bird I, 1964. Saint-Paul, Miró collection. Similar themes are continually represented in Miró, symbolizing the contact between heaven and earth.

72-73 The Ski Lesson, 1966. Saint-Paul, Miró collection.

74 Vase, 1941. Pottery. Paris, Galerie d'Art Moderne.

75 Terre de grand feu. Pottery. Paris, Galerie Maeght. A kind of monument, erected with wisdom, whose expressive effectiveness is measured by the precariousness of the established equilibrium.

76 Vase. Pottery. Paris, Galerie Maeght.

77 Bust. Pottery. Paris, Galerie Maeght.

78 Two-sided pot. Paris, Galerie Maeght.

79 Terre de grand feu, 1955. Paris, Galerie Maeght.

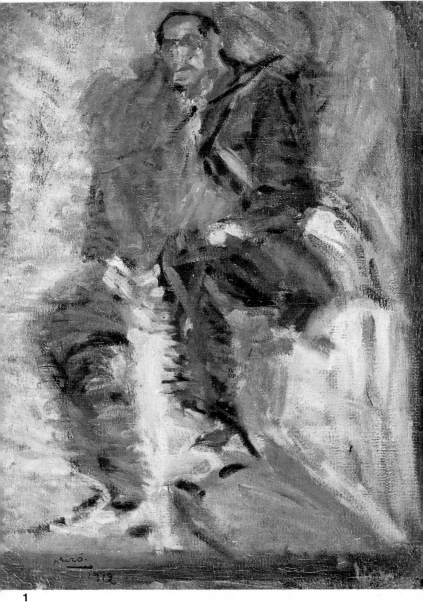

1

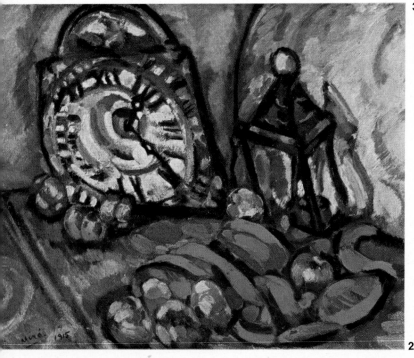

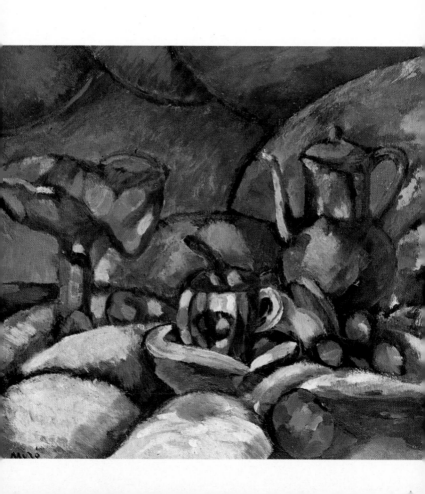

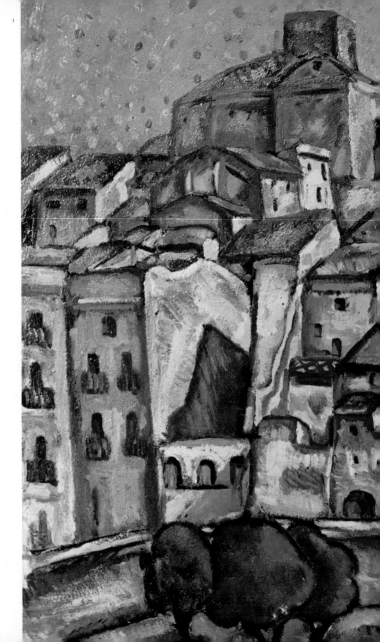

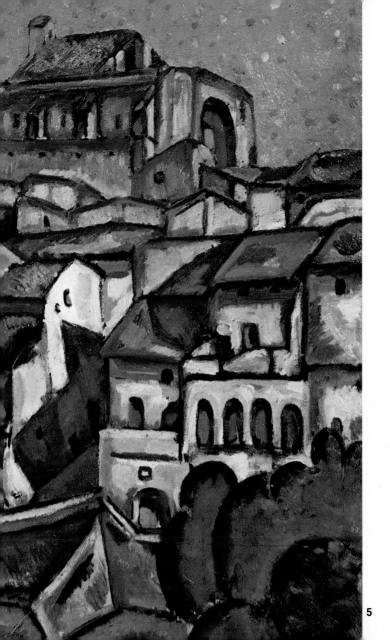

5

7

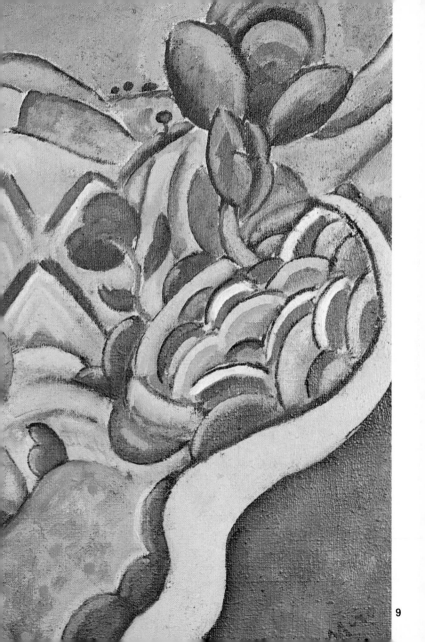

9

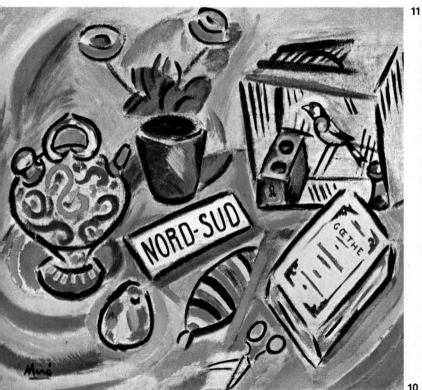

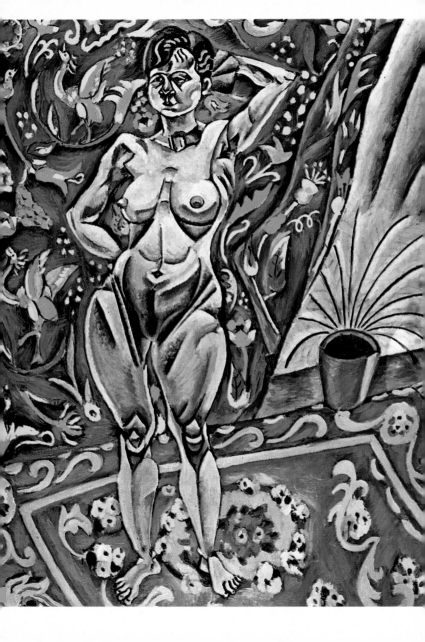

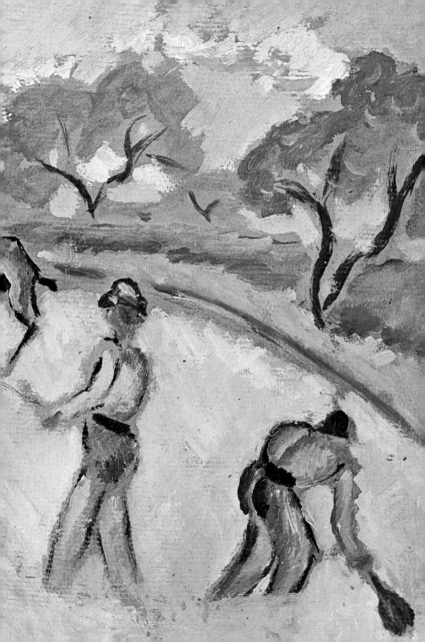

15

14

16

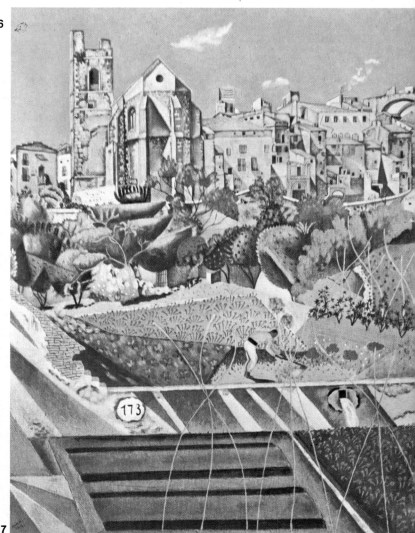

17

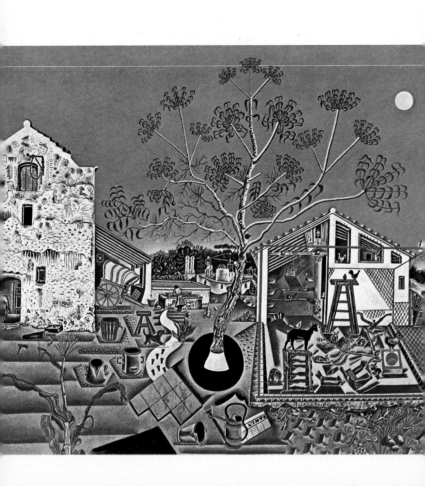

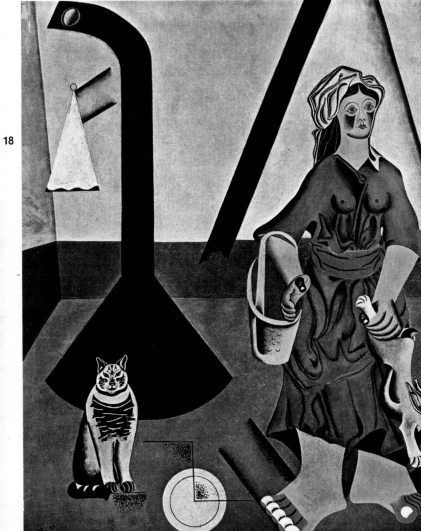

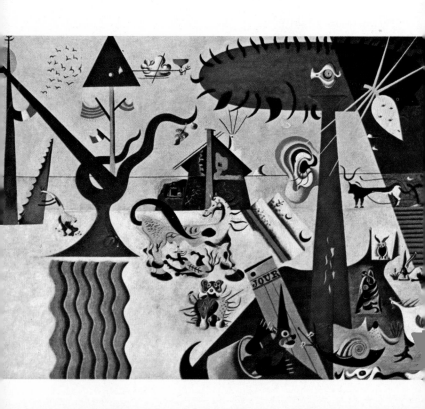

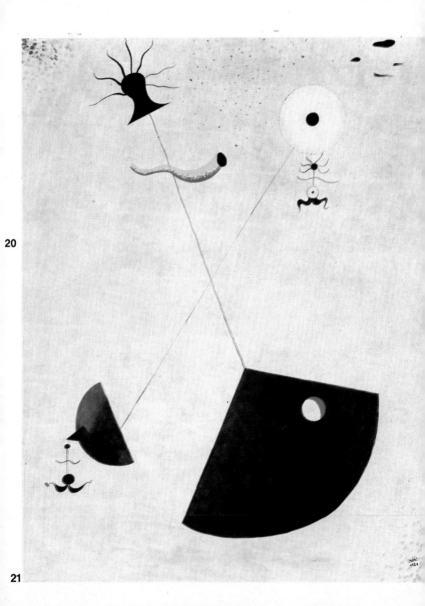

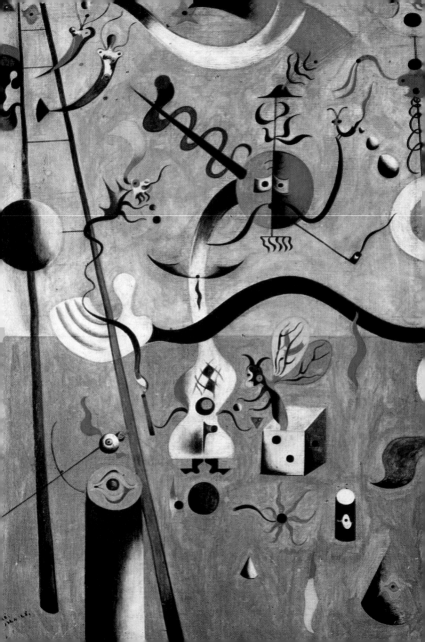

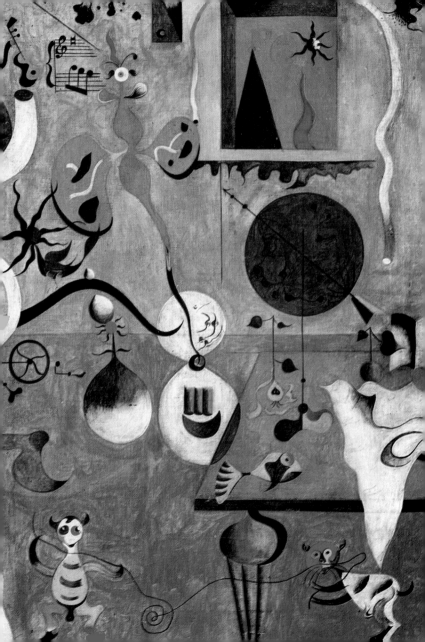

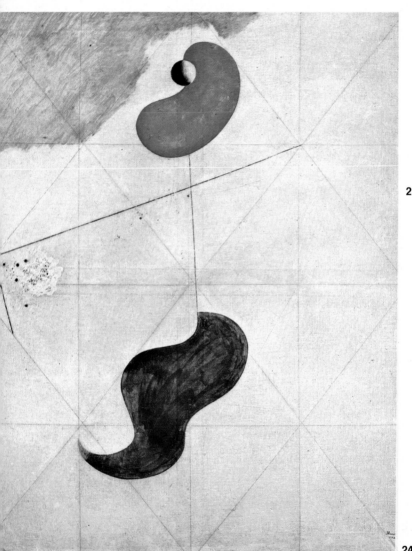

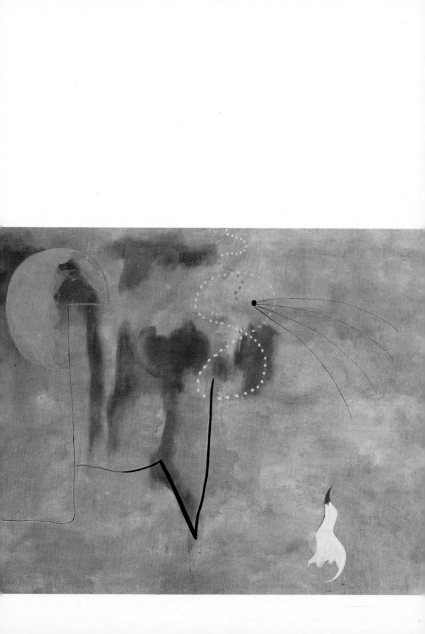

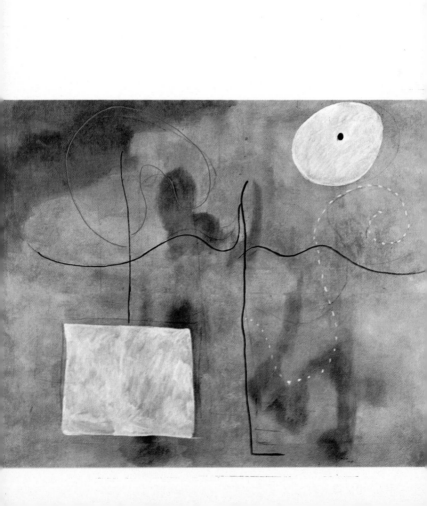

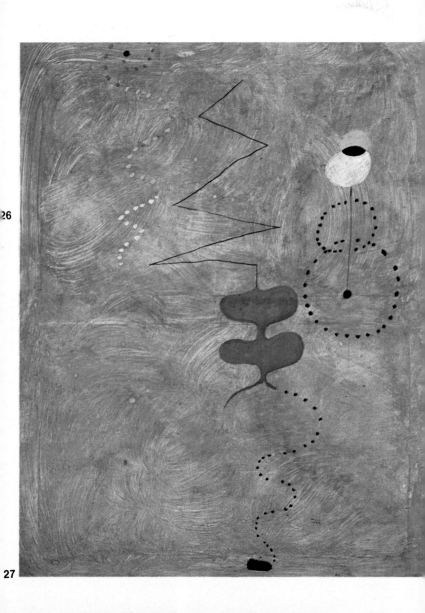

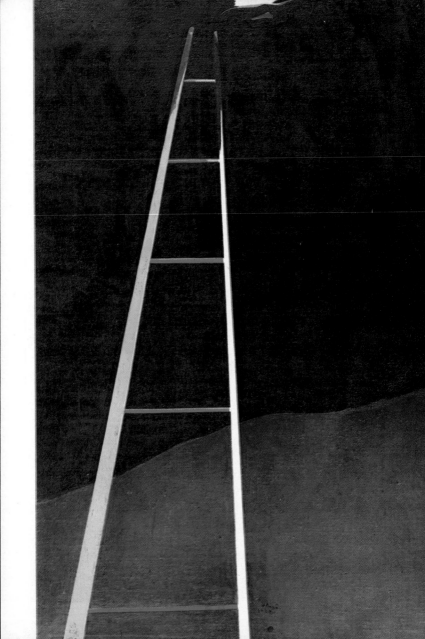

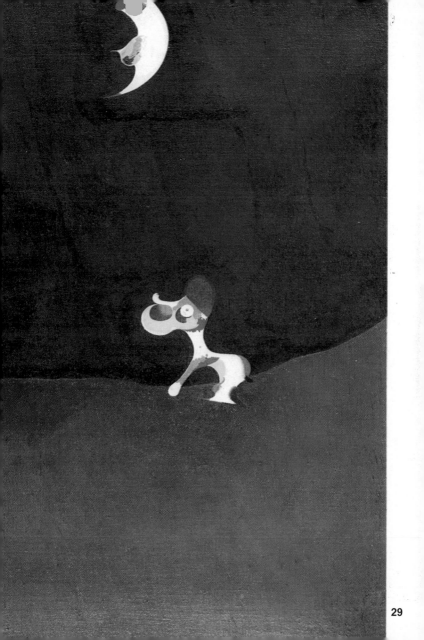

29

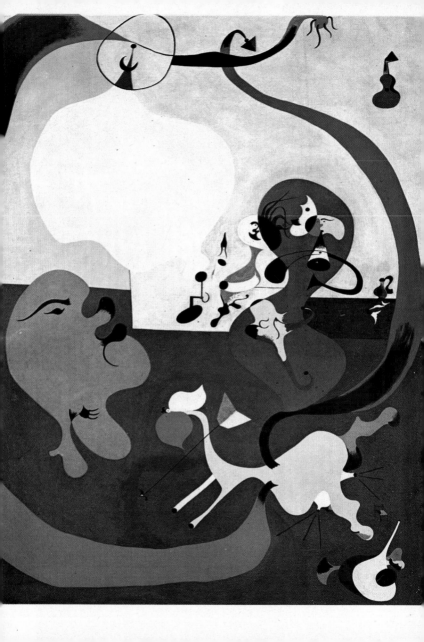

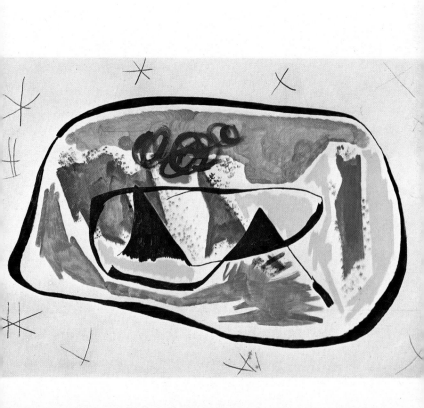

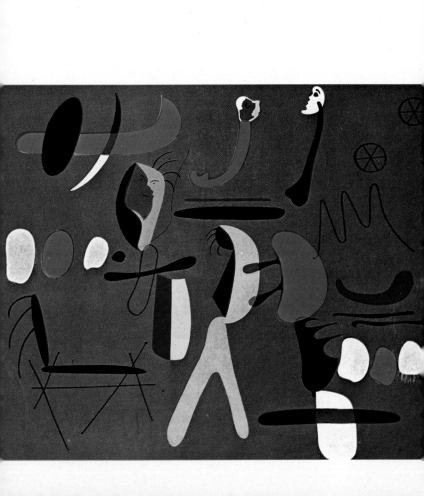

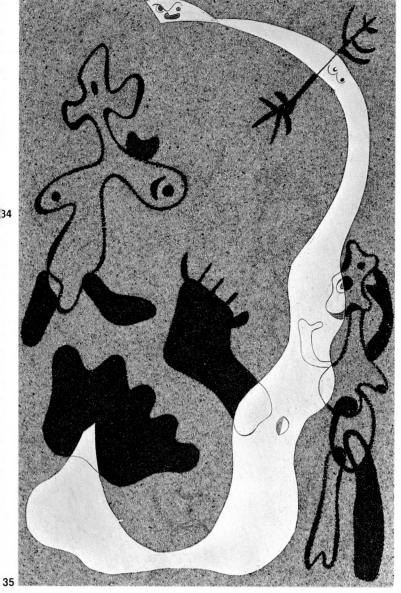

34

35

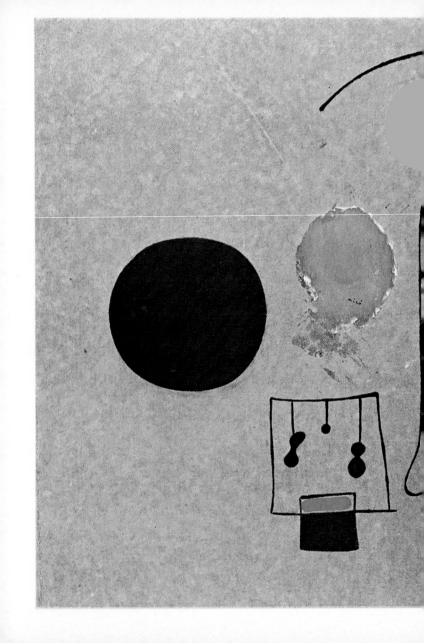

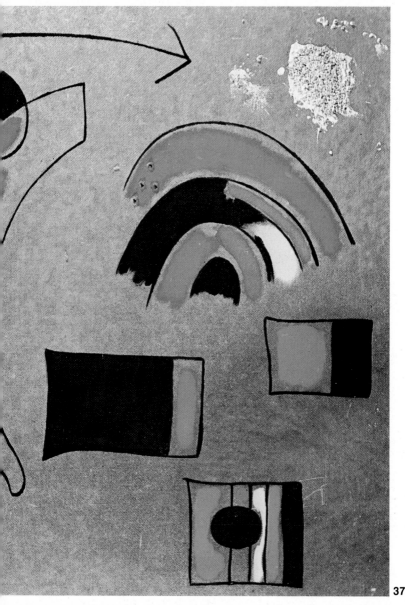

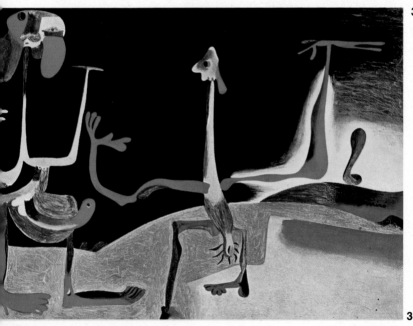

38

39

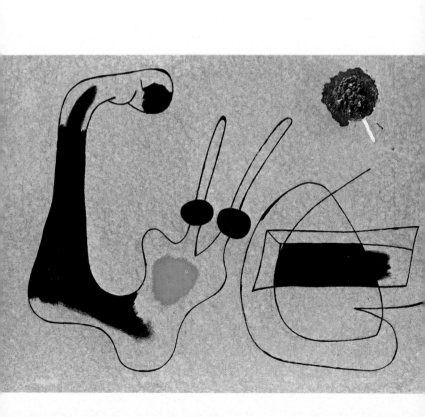

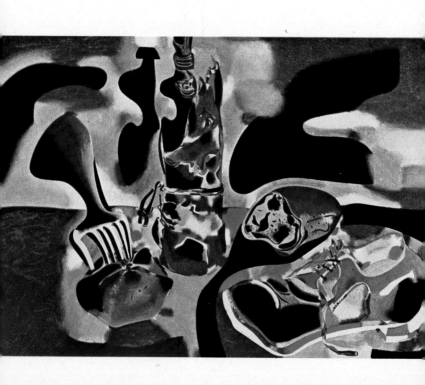

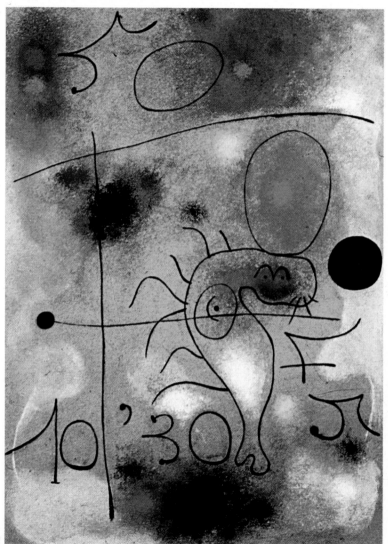

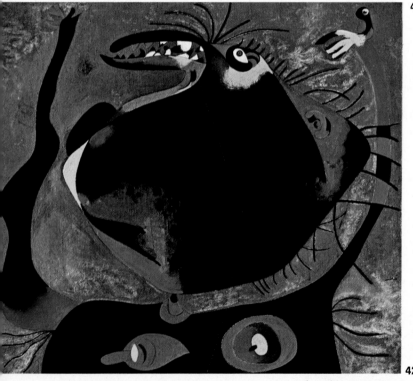

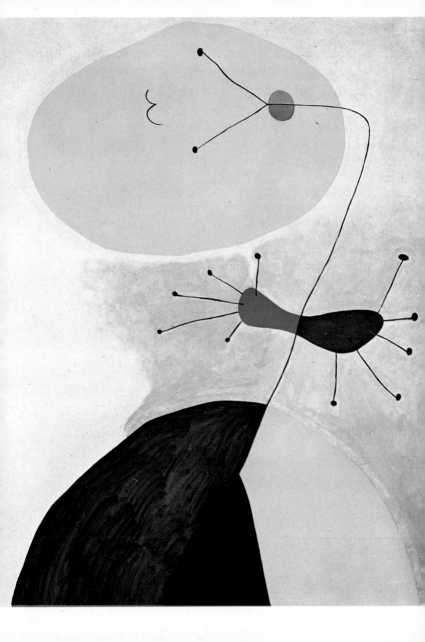

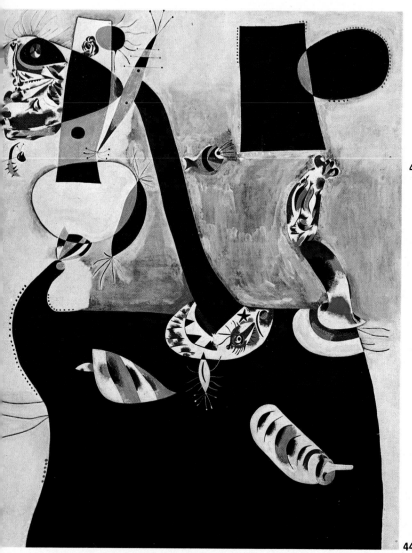

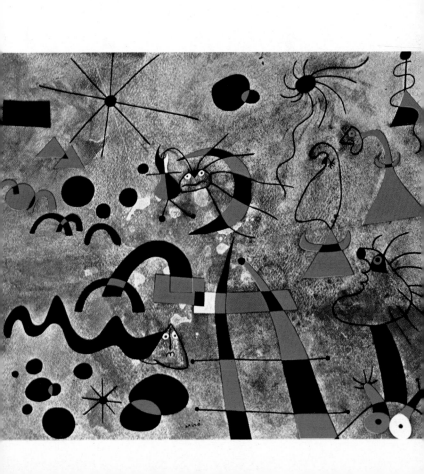

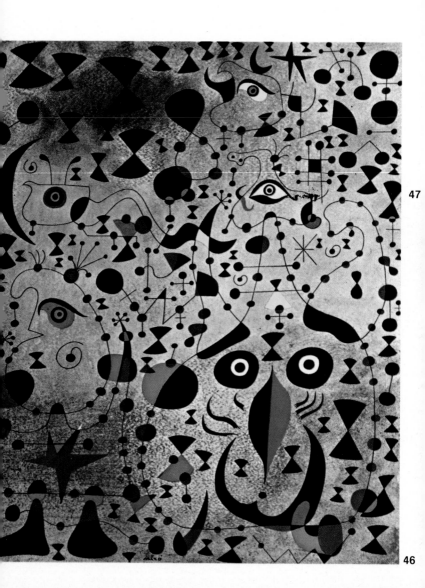

Miró

47

46

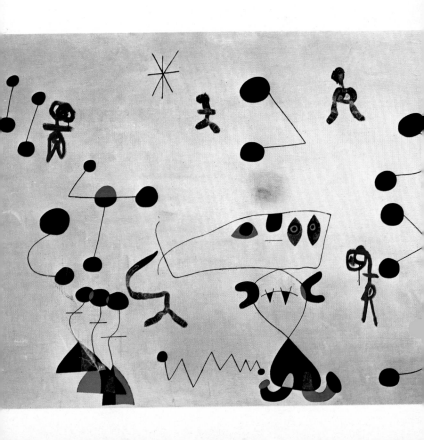

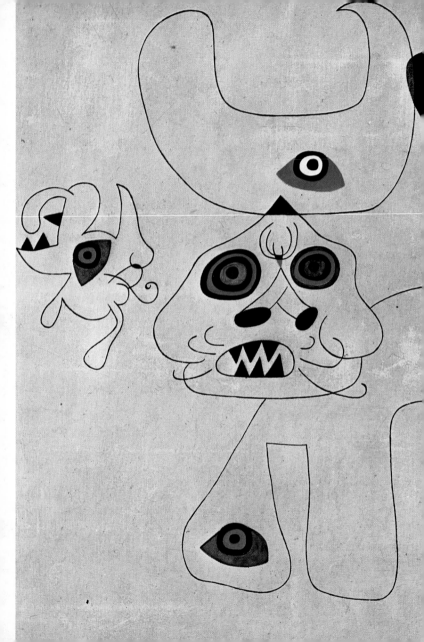

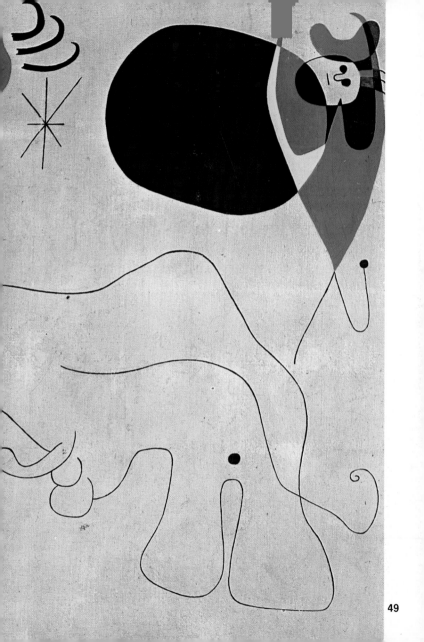

49

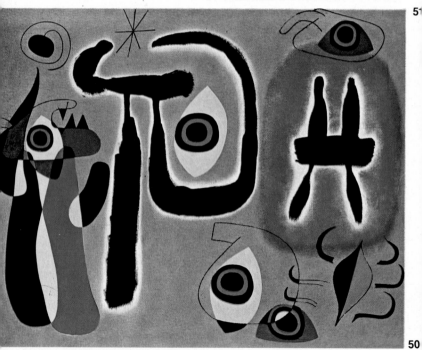

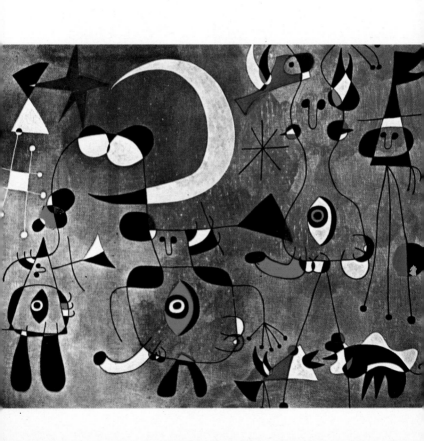

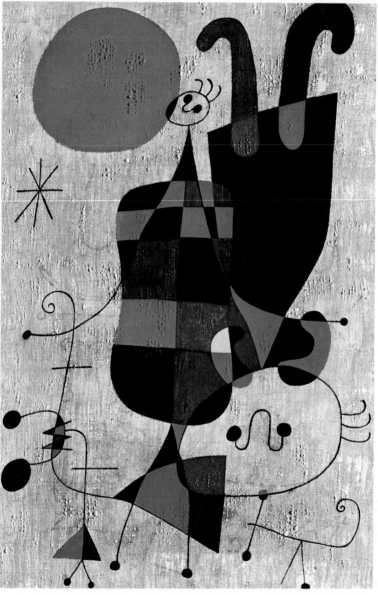

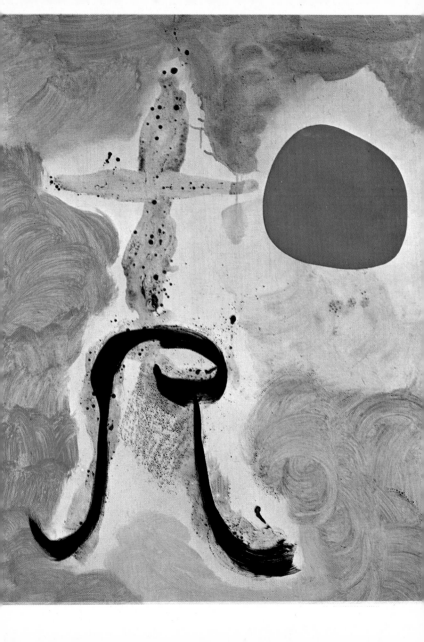

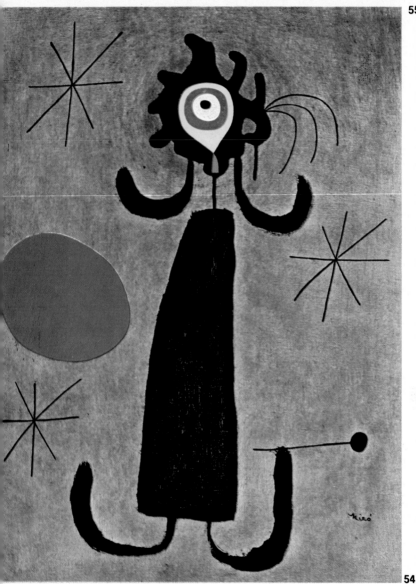

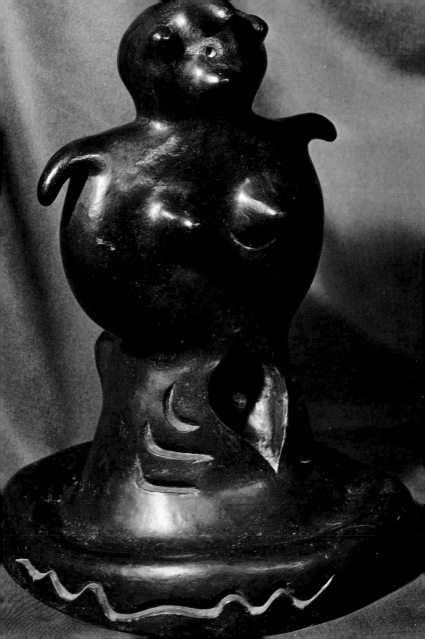

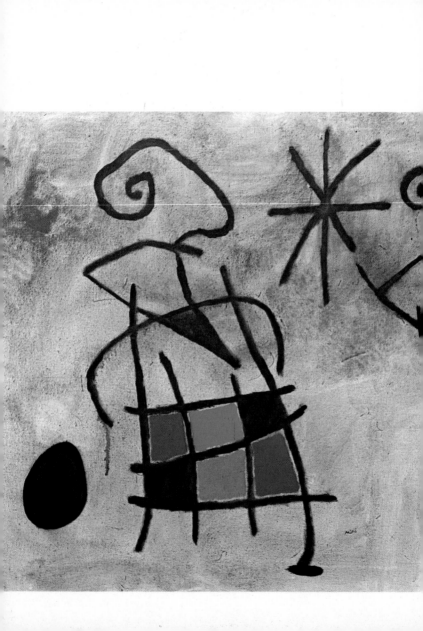

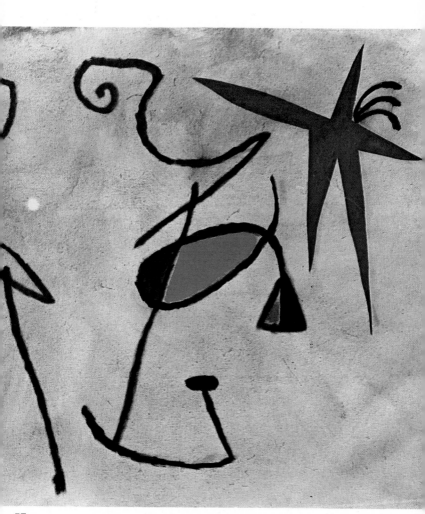

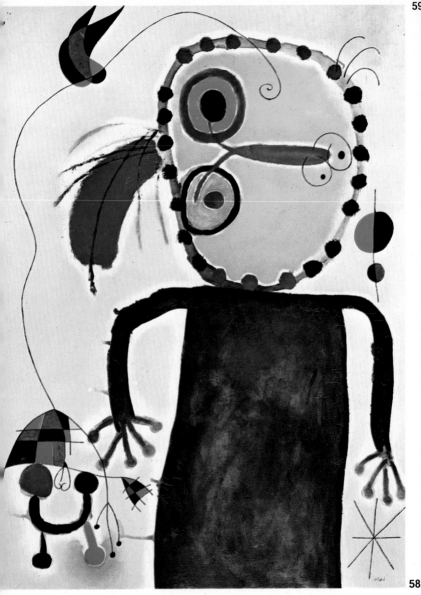

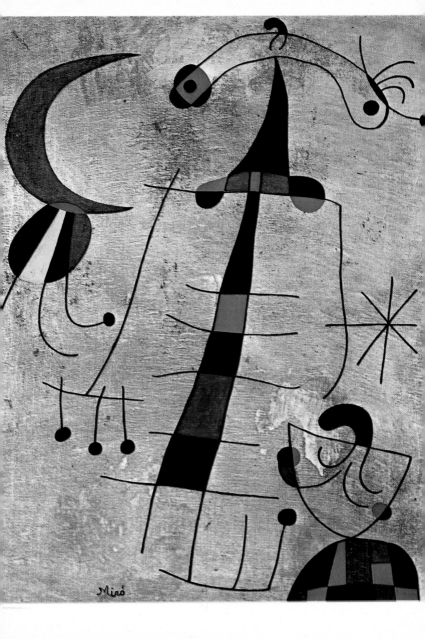

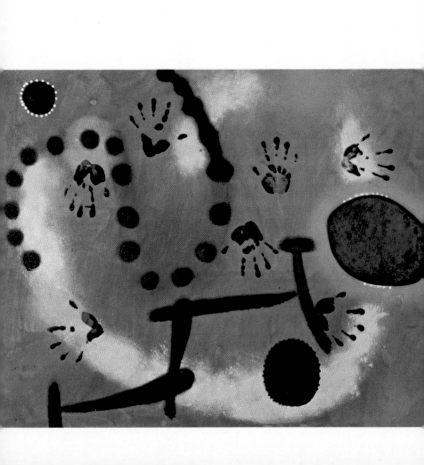

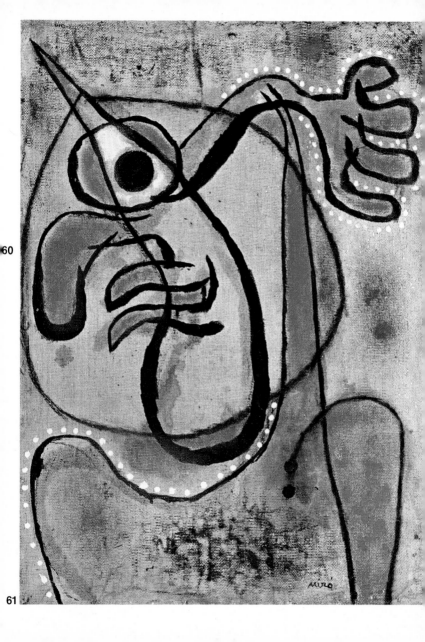

60

61

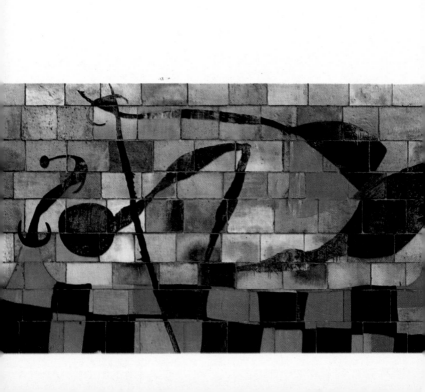

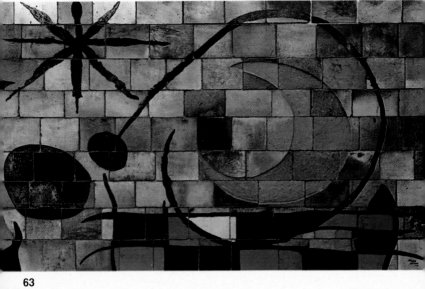

63

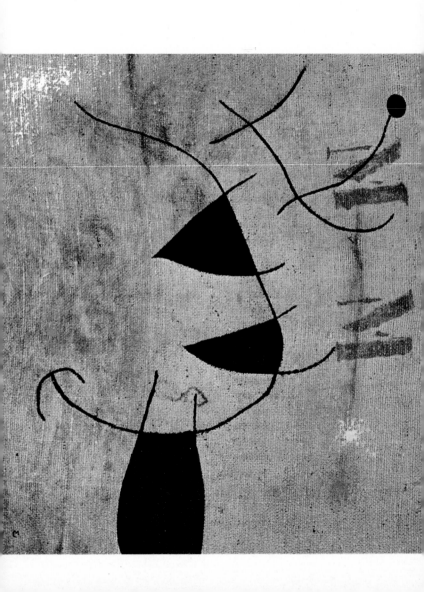

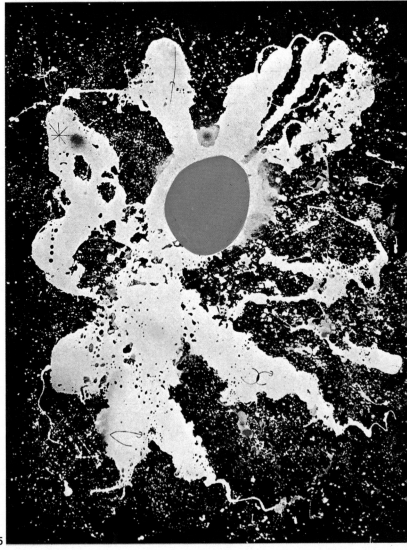

64

65

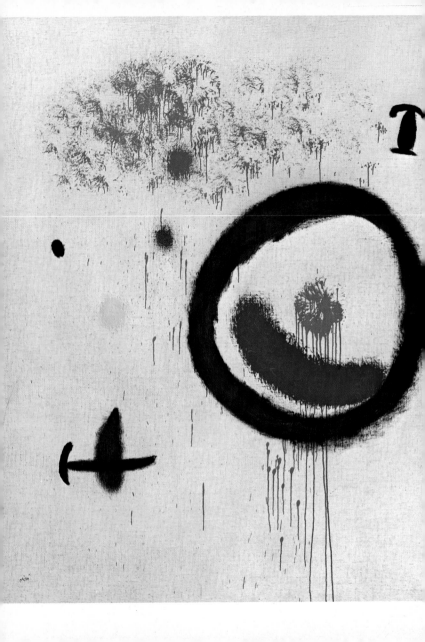

68

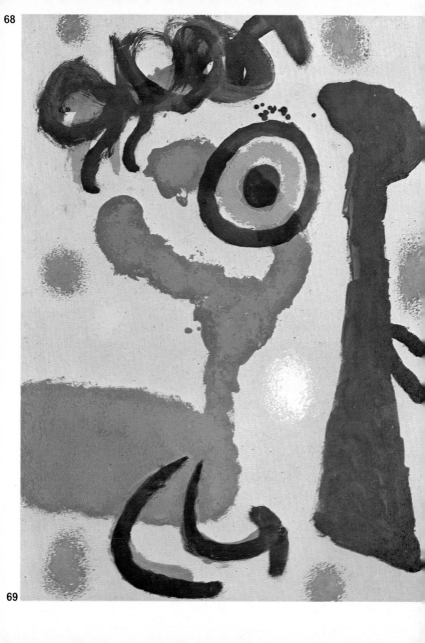

69

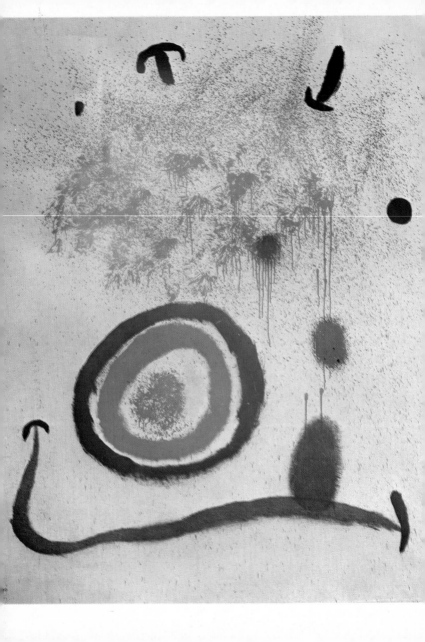

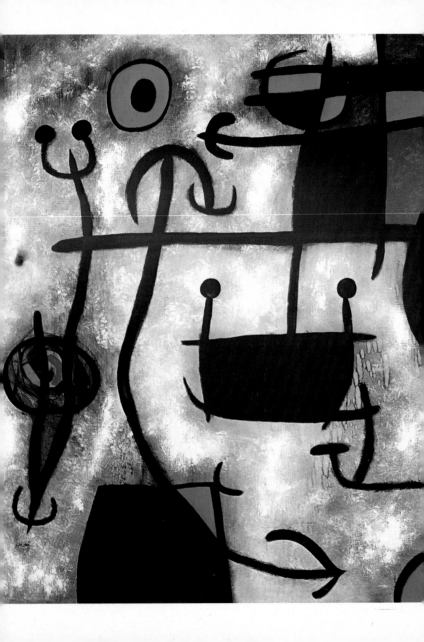

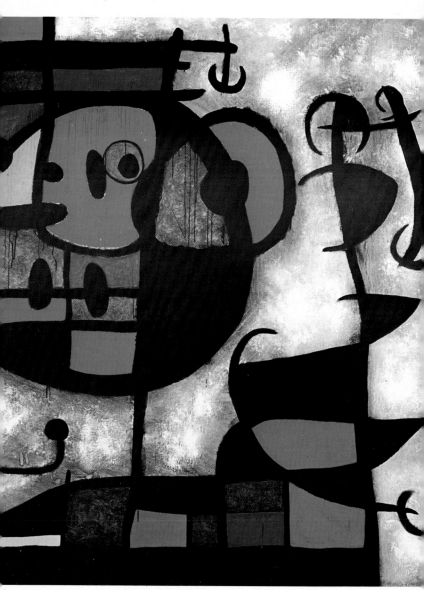

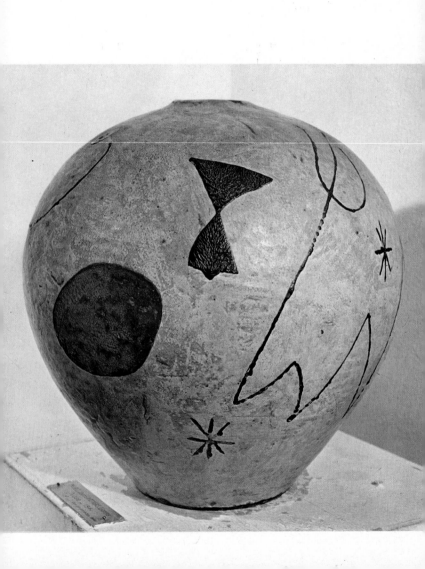

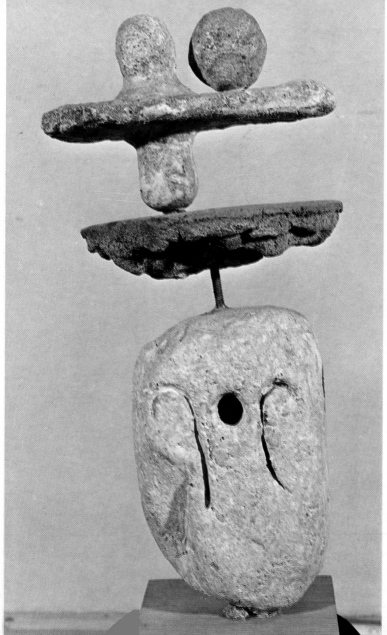

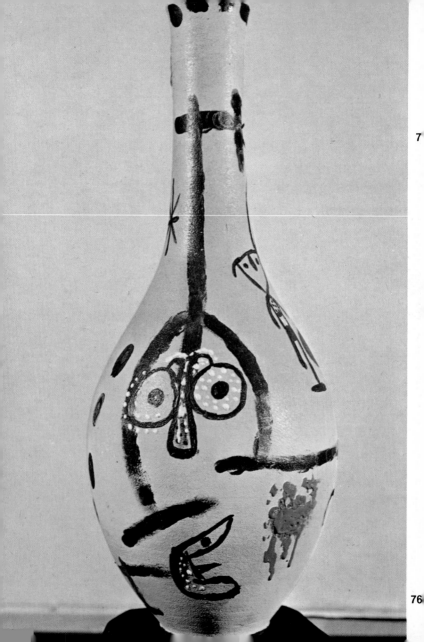

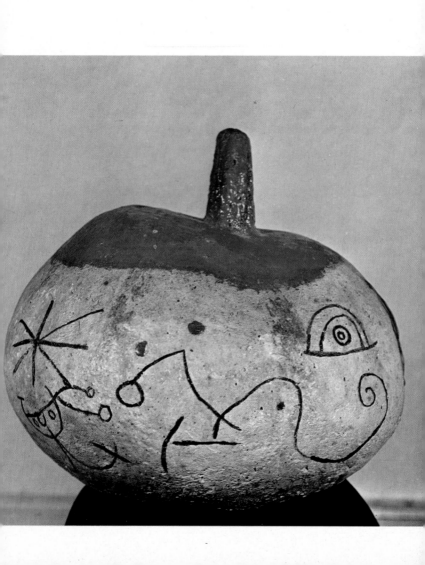

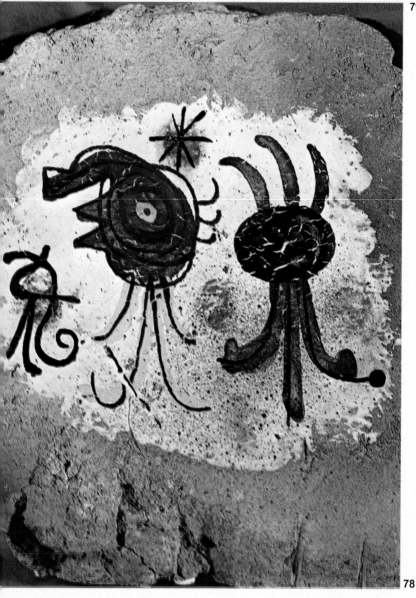

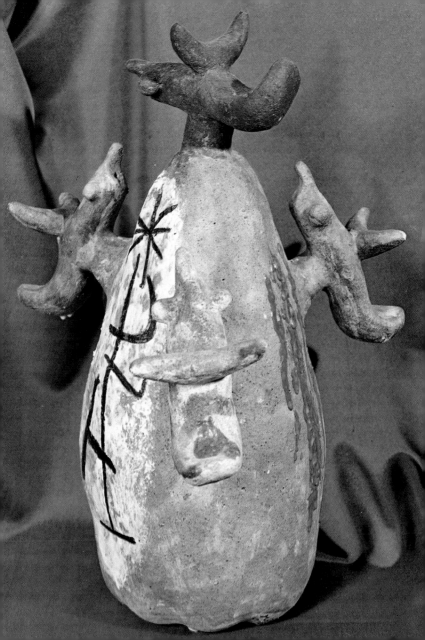